DREAM CLOSET

Published by

SECRETARY PRESS

New York, NY
secretarypress.com

Compilation — including selection, placement, and order of text and images —
and introduction copyright © 2015 Matthew Burgess; all texts copyright © 2015
the authors unless otherwise noted; all images copyright © 2015 the artists.

"The Game," from WHAT THE LIVING DO by Marie Howe
© 1997 by Marie Howe
Used by permission of W. W. Norton & Company, Inc.

ISBN 978-0-9883214-9-6
Library of Congress cataloging-in-publication data has been applied for.

First edition

MEDITATIONS

ON

# DREAM CLOSET

CHILDHOOD

SPACE

EDITED BY
MATTHEW BURGESS

MEDITATIONS

ON

# DREAM CLOSET

CHILDHOOD

SPACE

EDITED BY
MATTHEW BURGESS

*For my parents*

*"Every theory is a fragment of an autobiography."* — *Paul Valery*

I hid in closets, behind doors, and under tables. I crawled into the cabinet under the sink in my parents' bathroom—adjusting my limbs until I fit—and I climbed trees to find hidden perches with bird's-eye views of the neighborhood. My nickname was Bird. I made forts with blankets and couch cushions and I brought things inside: books, snacks, a desktop lamp, the extension cord snaking to the outlet. I craved the privacy of these spaces, the way they drew a temporary (if ineffective) boundary against intruders, and I sensed their mysterious power: at any moment, they could become genie bottles, spaceships, and magic carpets. The books I read were also filled with small spaces that doubled as portals to other worlds. Alice tumbles into the rabbit hole and discovers a vast subterranean realm. We enter Narnia through a passage in the back of a wardrobe, and James inhabits his flying peach.

In fifth grade, Mrs. England invited us to submit dioramas for extra credit on book reports, and I never missed an opportunity to turn a shoebox into a scene. I built a cemetery from a Nancy Drew mystery with real dirt from the yard and a cardboard headstone. When we learned about Joseph Cornell, the artist who became famous for his shadow boxes, I was fascinated — and jealous. It seemed like the perfect "job." Later, in high school, I discovered poetry. My oldest sister Michele had given Rilke's *Sonnets to Orpheus* to my sister, Karen, who was grieving the sudden death of her boyfriend, whom I adored. I wandered into this book and something happened; I couldn't have explained what the poems meant, but I had found a map that I needed. Rilke's sonnets taught me that a poem can be a kind of musical diorama: a box of words on the page that appears silent and still, but when you read it—or when it reads you—you slip into a parallel realm.

When I read Vladimir Nabokov's *Speak, Memory* in college, I was struck by his descriptions of childhood play. He recalls crawling through a "pitch-dark tunnel" between the wall and the furniture: "I lingered a little to listen to the singing in my ears—that lonesome vibration so familiar to boys in dusty hiding places, and then—in a burst of delicious panic, on rapidly thudding hands and knees I would reach the tunnel's far end, push its cushion away, and be welcomed by a mesh of sunshine." I knew that lonesome vibration! He goes on to describe another "cave game" that he played as a four year-old boy: "[U]pon awakening in the early morning I made a tent of my bedclothes and let my imagination play in a thousand dim ways with shadowy snowslides of linens and with the faint light that seemed to penetrate

my penumbral covert from some immense distance, where I fancied that strange, pale animals roamed in a landscape of lakes." These passages have the lyrical pitch of poetry, and they generate a shadow box effect: animated by the imagination, the enclosed space becomes a world. They also raised a question that would linger for years: Why do small spaces appear so often in stories of childhood? What might they mean?

Nabokov inserts a curious disclaimer before recounting these scenes: "It was the primordial cave (and not what the Freudian mystics might suppose) that lay behind the games I played when I was four. A big cretonne-covered divan... rises in my mind, like some massive product of geological upheaval before the beginning of history." The parenthetical within the declaration reads like a swipe or an eye-roll— Nabokov's attempt to preempt a Freudian interpretation by suggesting another. But in conjuring the "primordial cave," Nabokov posits a connection that feels as "mystical" as the return to the maternal body. The emergence from the dark tunnel into the bright room, and the dreamy hallucination inside the bed sheets: is the four year-old boy reenacting his own birth, or is he reenacting the birth of man?

In the opening pages of Virginia Woolf's autobiographical essay, "A Sketch of the Past," she describes one of her earliest memories: "It is of lying half asleep, half awake, in bed at the nursery at St. Ives." Woolf gives a rapturous account of listening to the waves and hearing the "acorn of the blind" moving back and forth across the floor, and in an attempt to capture the intensity of the feeling ("which is even at this moment very strong in me"), she employs a surprising metaphor: "[T]he feeling, as I describe it sometimes to myself, of lying in a grape and seeing through a film of semi-transparent yellow." To be minia-turized and suspended inside a grape is a fetal image; Woolf is *not* shirking a Freudian reading. In a later passage, she recounts another scene of enclosure that resembles Nabokov's tunnel of furniture: "How large for instance was the space beneath the nursery table! I see it still as a great black space with the table-cloth hanging down in folds on the outskirts in the distance; and myself roaming about there, and meeting Nessa... Then we roamed off again into that vast space." For Woolf, to be englobed inside a grape is to feel ecstatically released into sight and sound, and the vast dark space under the table is limitless. Is the small space, I continued to wonder, cave or womb?

Neither interpretation satisfied my sense that more was happening in these scenes, and as I gathered textual examples, my question became twofold: what do small spaces signify for the child, and what do they mean for the autobiographer recollecting the past? Some children find or fashion small spaces in order to create a smaller world—over which they exert a certain control—within the large one.

In a nurturing environment, the small space can be a site of exuberant, uninterrupted play; but when there are threats, the enclosure may serve as a necessary refuge—the child's attempt to carve out space for emotional survival. We hide ourselves in order to become unhidden to ourselves: inside the protective shell of enclosure, children can dream or play in peace. Small spaces facilitate the discovery of an interior, imaginative realm. We go in, and we go inward—and the spatial constraints dissolve or vanish.

The recurring figure of the child in the small space may suggest a lost union with the maternal body or some dim memory of the primordial cave; however, for the autobiographer recollecting the past, it is the place where the artist is born. Within the enclosure, the child discovers a capacity for daydreaming, storytelling or imaginative play, and it is the revelation of this creative agency that makes it a formative scene in the development of the artist. As Freud writes, "a piece of creative writing, like a day-dream, is a continuation of, and a substitute for, what was once the play of childhood." In a sense, this is the scene we repeat in the studio or study. The child's play becomes the artist's work.

Editing this book has given me the opportunity to engage contemporary poets, writers, painters, and photographers—many of whom are friends, teachers and even students—in a subject that has been central to my thinking and writing. When I wrote to contributors, I tried to describe the book in a way that was evocative without limiting the potential trajectories that people might pursue. The contributors to *Dream Closet* have not only broadened my understanding of childhood spaces, but they have demonstrated the incredible generosity of artists—their impulse to play along and their willingness to give freely in the spirit of shared vision. For the kid who loved dioramas, and for the teenager who discovered that art can be a map, this is nothing less than a dream come true: a book of explorable shadow boxes designed by a diverse tribe of kindred spirits.

Matthew Burgess
July 24, 2015

STANDING BEHIND THE     DOORWAY CURTAIN,
      THE CHILD HIMSELF          BECOMES

                                SOMETHING

FLOATING          AND

WHITE,                               A GHOST.

            THE DINING TABLE

                        UNDER

WHICH HE IS CROUCHING          TURNS HIM INTO

      A WOODEN IDOL

                  IN A TEMPLE WHOSE

PILLARS ARE THE CARVED LEGS.          AND BEHIND

                              A DOOR—

HE HIMSELF IS THE DOOR—

                  WEARS IT AS HIS

      HEAVY MASK, AND          LIKE A SHAMAN WILL

                  BEWITCH ALL

THOSE

      WHO UNSUSPECTINGLY

                                    ENTER.

Walter Benjamin, ONE-WAY STREET

STANDING BEHIND THE
DOORWAY CURTAIN,
THE CHILD HIMSELF
BECOMES
SOMETHING
FLOATING
AND
WHITE,
A GHOST.
THE DINING TABLE
UNDER
WHICH HE IS CROUCHING
TURNS HIM INTO
A WOODEN IDOL
IN A TEMPLE WHOSE
PILLARS ARE THE CARVED LEGS.
AND BEHIND
A DOOR—
HE HIMSELF IS THE DOOR—
WEARS IT AS HIS
HEAVY MASK, AND
LIKE A SHAMAN WILL
BEWITCH ALL
THOSE
WHO UNSUSPECTINGLY
ENTER.

Walter Benjamin, ONE-WAY STREET

## PRIVATE PLACES
Ron Padgett

When I was four or five I liked to hide under the dining room table.
A few feet away was the desk where my parents took orders for their
bootleg whiskey business. It's also where they counted the day's
receipts, some of which was in coins that they wrapped in paper
rolls for depositing in the bank. Unable to resist temptation,
I filched several of these rolls and hid them in the interstices of
the underside of the table. It seemed like such a delightfully clever
thing to do, and the secrecy of it added to the thrill. When my
parents discovered the missing coins, they gave me such a stern
reprimand that I never ventured under the table again.

•

Around the age of nine, I accompanied my mother and my aunt
Elda from Tulsa to Springfield, Missouri, to visit Elda's mother for
an afternoon. Because I had whined about the endlessness of a
previous visit, this time I was allowed to stay in the car and read.
With the women chatting away indoors, I took my stack of new
comic books, candy bars, and packets of Kool-Aid powder, opened
the trunk of the car, and climbed in, leaving the trunk lid raised.
The trunk was lined with soft blankets and quilts, probably because
it served as a whiskey stash. Being there was perfect, and time
didn't exist.

•

I was about the same age when my mother got a phone call telling
us that the police raiding squad was heading toward our house.
She grabbed the big ledger book that held the whiskey business
information and told me to run out and hide it in the doghouse.
Custom-made by my father and a fellow bootlegger, it had an
entrance large enough for a child but far too small for an adult.
I squeezed through it and placed the ledger behind a sliding panel
on the underside of the roof. In the dim light I lay back in the
fresh straw, inhaling its aroma, and felt immortal.

•

At the age of about twelve, when I was taking a class in American
history, I decided to secede from the Union. So, with my friend
Dickie Gallup, I chose a patch next to the house—a rectangular

area of around fifty square feet that was partially hidden from street view by a dogleg in the house's exterior. We had a brief ceremony in which we declared our independence, even giving our new country a name, something like The United States of Us. We walked around in our new country, exultant and free. An hour later my mother told me about the existence of the property tax, which sent me into a foul mood. I never went back to the United States of Us.

·

At the age of fourteen I began to yearn for a space even more private than that of my bedroom, and so, with my parents' consent, I bought some one-by-six planks and installed them as a crude floor to cover an area of the overhead joists in our garage. To climb up there one used the permanent ladder on the wall that led up to the entrance of the crawl space over the house proper. I hauled up stacks of science fiction magazines and back issues of a propaganda magazine that I was receiving from the Soviet Union, along with a short-wave radio that brought me programs from all over the world (the BBC!), as well as the pop music of the day (Fats Domino!). Because of the summer daytime heat, I spent the cooler evenings up there, free from the prying eyes of my parents, who actually pried very little.

·

At some point in elementary school one of my teachers showed us a shoebox with a small hole in one end and asked us each to take a peek. Inside was a miniature installation depicting the baby Jesus and Mary in the manger, accompanied by farm animals and hay. For a moment I felt transported by my amazement that another place and another time could magically exist inside that little box. Many years later I wrote this poem:

*Framed Picture*

The baby Jesus
was born in the corner of a cardboard box,
the shoebox
my cowboy boots came in,
all sparkling with rhinestones
and echoing with the voices of German maidens
off in the hills behind the castle:
the red rose blooms in her cheek
and she smiles to the blue heavens.
It is 1819.
What am I doing here?
Tending the trellises, culling a few yellow roses from the vine,
carefully wiping the watercolor pigment off my hands,
heading back up toward the house.

HENRY
Brett Bell

# IN HIDING
Michael Cunningham

As a child, I dreamt of being pursued.

I was never entirely sure about who was after me, or why. I knew, somehow, that too much logic would spoil the effect.

Which means that I can't describe my adversaries now, because I couldn't describe them then. I can tell you that they were not men; they were certainly not men in suits and sunglasses. They were… shapes beginning to manifest among the bracken in the modest stand of woods behind our house. They were dark coalescences of malevolent intention, inventing themselves in our basement.

If these hunters were, of necessity, vague to me, it naturally followed that the purpose of their pursuit was equally murky.

I had, it seemed, been entrusted with evidence regarding… something crucial… whatever it was that inspired sunrises and constellations, whatever decreed that our house would not catch fire, that my father's tools would reside peaceably within their penciled outlines on the pegboard, that Mrs. Schneider would take her ancient dachshund for walks every few hours even though neither Mrs. Schneider nor the dachshund took any visible pleasure in it, or achieved any discernable results.

The world struck me as breakable, or, at the very least, subject to breakdown.

Who knows from whence these childhood fears arise? You could spend your entire life tracking them down, and even if you found the solution, what, really, would you have gained?

I was also, like many children, in love with rules, the more arcane and opaque the better. And so (again, I have not brought the reasons with me into my adult life, if reasons ever existed) the fiends could only find me when I was hiding. I needed to conceal myself every day, in spite of the fact that information regarding my home address, my school, and my daily route to and from same were depressingly available.

It was, simply, one of the Enemy Rules. Because one is being sought, one has to hide, but it is only by hiding that one renders oneself available to discovery.

My hiding places, naturally enough, needed to be changed regularly. I huddled in the stable of our next-door neighbor's deceased horse until I began to suspect I was on the verge of detection, at which point I relocated to a forked branch in a tree that belonged to the neighbors on the other side of my family's house. I moved from there to the storage closet that opened strangely off the landing of the staircase in my family's house (yes, I did contemplate the irony of

finally being captured as I crouched under a box labeled TWINKLE LIGHTS); then to the recently-dug foundation of a nearby house that would, as it turned out, never be built; then to the striped shade under the bleachers at the Little League field.

I was probably ten or eleven when I realized, rather abruptly, that no one was looking for me—no one, that is, with sinister intent. Like many childhood realizations, it seemed to come from nowhere, though it must have had something to do with getting older and, in getting older, with understanding—through the brute accumulation of days and nights—that the world might be subject to ruin, but that global extinction, should it occur, did not stand or fall according to some secret I held, a secret so deep it was unknown even to me.

What was vital on a Tuesday was, just that suddenly, foolish and embarrassing on a Wednesday.

I stopped hiding. I released my antagonists, and they released me. I lived as a free young citizen. I no longer imagined myself to be a singular defense against disaster. I realized that if catastrophe struck—if the constellations failed or the house burned down— I would be as surprised, and as devastated, as everybody else.

And so it became apparent that I was neither more nor less than a member of the general cohort. My movements were not subject to scrutiny; I possessed no precious knowledge that, if revealed, would unmake any earthly manifestation, from the sunrise to Mrs. Schneider and her dachshund. I was not unusual, I possessed no secrets; there was no particular reason to hunt me down.

It was a dreadful revelation. I'm not sure if I've ever fully recovered.

## THE RULE OF BURNED THINGS
Melissa Febos

In 1989, my father rode the seas. My mother wept downstairs.
Crouched in my dark closet, I burned.

My secret pet was a Mason jar, hidden in a gift bag behind my unworn
dresses. Hungry, goatish thing, I fed it scraps of paper, string, tufts of
stuffing from my pillow. I struck matches and dropped them in. Singe
of sulfur and *alakazam*—my own hair curled ecstatic.

Plastic burned to molten liquid, cooled to black diamond. Sometimes,
I fished these out and tucked them into the velvet pouch of my mouth,
still warm. Even then, I knew: fingers are dull instruments—some
things can only be felt by tongue.

Not a girl who caught butterflies in jars. I made my own: a gray bit
of nothing lit flashed its orange wing, glowed the dark brighter than
any lightening bug, then *poof*, gone to ash.

O, to change that way! Spark and flash of becoming, sharp scent of
shape shift. The rule of burned things was smaller, harder. But not
me. The slow-motion bonfire of my child body swelled bigger, softer.
I couldn't quench it.

My family changed, too. Dropped match of my father's absence.
Dropped match of mother's missing. Struck match of my body—
I dropped it all over town. Our house burned but humans don't
harden, we break open—split to the wet and salt.

In the closet, I burned for five years. My bits flamed in the mottled
glass, and I studied their motion, as if I might learn to reverse
my own.

All those hours, I never learned to shrink myself, to harden, to undo
any human opening. Only that burn was not ruin, ash not gone.
Those smudges on everything.

At 34, I still drop matches. *Abracadabra*. Watch the paper writhe.

The dream
closet is no longer
cordoned off.
It vanishes easily (the active phrase assumes direction)
Happy as a brain dead heiress,
the entourage involved forever turning its back,
unveiling of arrival,
glimmering beyond a list of books that have disappeared,
 *Felix of the Silent Forest* is still missing.
It is one long wait for the elevator.
My empty mind faces a mirror.
No objects but audible words formed death metal,
solid gold and country blues.
The camera still unannounced.
Another misfit that would recognize my eyes.
Mascara marbled sweat
beyond frightened
only fierce.
Uninterested
in story
only how it's held.
Calling up receptors of individual visions,
clear to the center of the gallery,
Pleasing perfect strangers,
O song to lift our spirits into tanzanite teacups,
Take a walk outside.
A chance meeting as he demanded
And argued his way through a letter,
that I was a double of my self
and owed him money on top of his outrage.
Sported a glow in the dark moustache
to throw him off.
To lock the door behind me
alone against my charts and  untrained voices.
I read poetry as if from coloring books or paint
with water
joining the raised golden dot.
I must have slept with no way of getting in touch.
I woke up to my lover then breaking down the door.

THE VANITY
Christine Hamm

*1971*

I tuck my head between my legs and roll
into your belly, almost banging my head
on the "∪" of the sink trap. There's a sharp
piece of metal inside you, cutting my knees
and feet. I can never find that screw with the lights
on. I want to hold your hand, but I can't find it in
the dark. The water pipe in the wall twangs like a slowly stretching rubber band.

*1980*

I tuck my head between my legs and roll
into your belly, and you hold me, humming:
*Wearing a blonde afro wig. A dress of paper flames.*
*Smeared peacock eye shadow. A limping girl.*
*You can do anything to her.* Lilac guest soaps shaped like carnations.

*1987*

I tuck my head between my legs but can't fit that way.
I creep into your hot belly. My knees jam against plywood,
my toes smash into a corner. Toilet paper and shreds
of red butterfly wallpaper. My rusted razor blades. A clay
paperweight with the shape of my brother's hand. Snow
sifts into our tiny wrecked disco, the scent of fake apples and talcum powder.

## MORNING IN THE BEDROOM WITH FIVE MOONS
Aram Jibilian

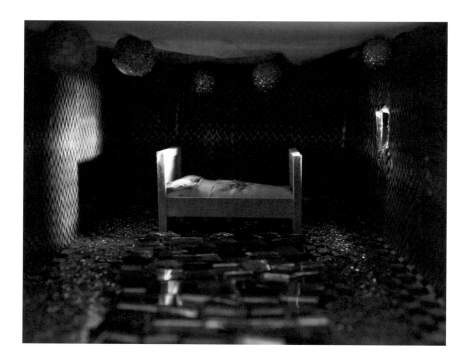

# UNICORNS
Emily Moore

"Let's look," she'd say, and hunch down by the guest bed,
  lifting the scalloped bottom of the comforter
  to shine her flashlight beam across the rug.
I squinched down, too, my right ear horizontal to the floor,
  my young grandmother on her gin-thin hands and knees.
Her flashlight beam lighthoused across the carpet
  revealing puzzles, shoeboxes, and suddenly a flock
of unicorns piled up together: some with gold felt horns
  stitched into spirals, blue-swirled button eyes,
and felt eyelashes; a tiny white one with red velvet hooves
  and ears; some standing on four legs; one sitting upright
with her knees curled to the side; most with plastic
  toy store tags still ringed into their ears.
When we weren't visiting, she lived alone
  inside that house that smelled like pine needles and ash.
She had her stroke alone, and when I was eleven
  Dad rented a U-Haul and we drove up to the Catskills,
packed her furniture, and gave away the dogs.
For seventeen more years she smoked inside a nursing home
  in New Rochelle, this woman who loved fields.
She weighed seventy pounds, then they cut off her gangrene leg
  and she weighed sixty-five. But back when I was nine,
she held the bedspread up, her wrist twitching
  as dust flickered in light. I watched it fleck
silver and white, and through the haze, the unicorns,
  pushed back against the wall, gathered together, breathing.

## CANOPY

Emily Moore

While other girls played blacktop games
I built myself a shady fort
inside an evergreen or ripped
off rhododendron leaves for Tom
and me to use as cash we passed
from hand to hand in waxy piles
until the year that Ava built
a lean-to in the woods and thatched
it thick with pine and clumps of earth
and I skipped lunch to help or trailed
Alyssa to the grove the oaks
wind-wild overhead then spent
nights looking out across the fields
through willow branches thin as threads
each skinny oval flickering
fish-silver in the dusk the way
the canopy shone overhead
the night that Lane and I had sex
against a birch in Central Park
my ankles buckling beneath me
slipping off the path.

POETS

CONVINCE

US THAT

ALL

OUR

CHILDHOOD

REVERIES ARE

WORTH

STARTING

OVER

AGAIN.

Gaston Bachelard, POETICS OF REVERIE

POETS CONVINCE

US THAT ALL

OUR

CHILDHOOD

REVERIES ARE

WORTH

STARTING OVER

AGAIN.

Gaston Bachelard, POETICS OF REVERIE

## IN THE AMERICAN DREAM ROOM
Sheila Maldonado

I hoard
all the Barbies
blonde 'fro Barbie
the Jane Fonda one
the one in the pink
and purple peplum
who taught me
the word 'peplum'
the Victorian one
in the lace collar

they're in
the dream cottage
on the floor
in my dream room
ghetto princess room
with the frilly canopy
pink and white linen
all the stuffed animals
framing the bed
my plush safari

I deserve
all the pink
all the lace
all the collections
I get it all
shut the sibling
the cousins out
for as long as I can
they will not raid
the dream fortress

I arrange the dolls
just right
the ladies on the
plastic couch talking
the customers at the
dream store
on the top floor
of the cottage

picking out chokers
and wide brim hats
at the pool
damn right the pool
next door
just a bit longer
than a Barbie leg
more bath
than pool
there go dolls ready
with bathing suits or
bathing suit-like attire

the cousins never
get that right
they put Victorian lace
collar Barbie there
she does not
take sun at all
they bring the jewels
from the store
to the pool
I might let that go

in the American dream
room cottage girlhood
I am meritocracy Barbie
I do it right
to therefore get it all
I wear a swimsuit
under my full faux
silk pink skirt
equipped for
the Puritan pool

my brother sleeps
in the living room
he came late
to the dream
I was here first
one day
we will share
one day
he will take
one day I will leave

I will cross the street
to the dream sea
larger than any pool
the sea at the end
of the city where
I see Staten Island
and England
the Barbies
in the bath
drifting away

the large water
ripple talking
the ships far moving
in long blinks
distance I covet
gray green haze
sand sea sky
position me
on the boardwalk
facing east just so

BREAKER
Joanna Fuhrman

A black wave surrounds me in slow motion.
I am dry, warm inside a claw-foot bathtub
carved from an idea of art. The black wave
is the whole ocean, humming a single note.

I am dry, warm inside a claw-foot bathtub.
I wonder, how can I be safe when the wave
is the whole ocean? Humming a single note,
my mind is the ocean and I am safe within it.

I wonder, how can I be safe, when the wave
is larger than the shore and swallows the tub?
My mind is the ocean and I am safe within it.
I smell another wave, years away. The water

is larger than the shore and swallows the tub
forged out of thinking and solid as bone.
I smell another wave, years away. The water
is the size of everything I thought was the world.

Forged out of thinking and solid as bone,
the bathtub is a halo, keeping me safe. The wave
is the size of everything I thought was the world.
It's just a wave, and waves disappear.

The bathtub is a halo. Keeping me safe: the wave,
now just an idea. I breathe in the clean air.
It's just a wave, and waves disappear.
I float on the air inside the giant bathtub.

Now just an idea, I breathe in the clean air.
A black wave surrounds me in slow motion.
I float on the air inside the giant bathtub.
Carved from an idea of art, the black wave.

## AT TWELVE
Christina Olivares

It's simple: drop a penny into the deep end of the pool then jump
down to the bottom and bring it back up. Repeat. The world is
blurred, then erased with the thickening weight of water as our
bodies push downwards, driving towards goal. No matter how shiny
or black, penny, a switchblade, a pair of sunglasses thieved from a
table, keys. What matters is our slim fingers moving towards the glint
or dark of the target. No competition in a traditional sense. We go
and go. Tough if you're distracted as it falls, or water seduces light
long enough to blur your sight. Yards that are fathoms, pressure that
balloons, the chlorinated water designed to lift one back up to the
surface and to lit air. A natural phenomenon that approximates
tenderness: to float. If nothing else does, the water resists drowning
you. Still we try. Fling ourselves. Towards ourselves. Uncollected.
Down there where nothing stays long. Where everything we miss is
drained and sorted into foreign hands. We push towards a silence
that would keep us safe. No. Lifted again into the daylight where there
is no grace. Dive. Belong to the violence that blooms in us.

# MY PARENTS' BATHROOM
Jason Zuzga

One thing I would do was shake talcum powder into a Dixie cup of water. It created an odd film; I could stick my finger into the water and my finger wouldn't get wet. I'd stick all sorts of things into the water, Q-tips and a bit of eye shadow off from one of the nestled bricks in a compact. Eventually the bottom of the Dixie cup would become so soggy that the paper would tear. The water with all its morsels would drop into the sink. The cup pulp under hot water reduced to nothing, all the paper dissolved and down the drain except for one thing, a clear plastic disk that had guarded the base. I could put it on the back of my hand. Icouldn't see it, but I could feel it there until it dried.

I could watch the pool from the bathroom window. Our back door neighbor, Mrs. James, would come in the late afternoon, after we were done swimming and had gone inside to watch *Star Blazers* and *General Hospital*. I would take a shower in my parents' shower and then watch Mrs. James do the backstroke through the blinds. She was an adult and alone in the pool, with arms that loped up and through the air, down intothe water, like the power of water and trees. There was a confidence inher large blue bathing suit that I couldn't fathom. It made my feet feel small. They weighed bare on the serrated air vent that poured air-conditioned air around my ankles.

Hamper and scale. Hair dryer and curling iron. The plug-in makeup mirror with variable lights that could make your face look like it was evening, like it was inside, like it was spring.

I would stoop down and put a container of soap onto the drain so that the water began to fill the shower stall. I would take the Paul Mitchell shampoo and drizzle it all over myself so that I smelled like a coconut afternoon. I would sit down on the yellow tile and let the shower shower me, drawing my hair down in waving lines over my face, and try and breathe, the watery breaths, the taste of pipes. All the steam that I was cubed in thinking of the tropics, where people would walk around in linen skirts through the fanning palm fronds, sun glinting off the water, the opalescent whale song replenishing everyone's skin. I would lean forward and rest my forehead on the tiles and the water rivulets down my back, held by the water, the plumbing of the whole house working all around.

NIGHTWOOD
Wayne Koestenbaum

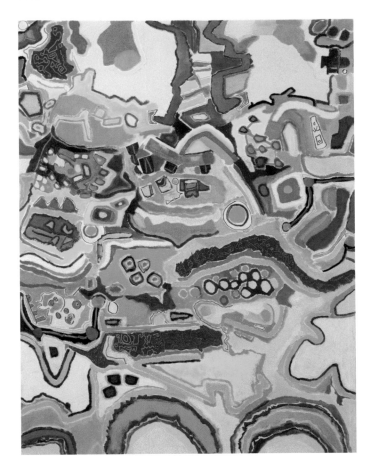

## POPSICLE
Eileen Myles

after the bearded
men &
the coffee
cleaned up
pure streams
navigate your hands
our son is a puzzle
the buildings have
met; your long
legs navigate
the kitchen
sweet clatter
cluck our eggs
are done. Now everything's
heading to the
forest to feed
on me.

4:3
Ian Hatcher

four tethered strings
whir click remain three green living branching apparatus
texture of wooly carpet fibers destranding threading
tongue glowing smooth paint over

                              over

no private ownership over
detuned unchained finely woven
strings in rotation around one another
finely spaced parallel patterns
which with distance find togetherness
and with closeness separation
as might any matter separate
into tiny component glowing atoms
fuzzy with what they contain: implications
of four pixelated universes
and three boundless ones
in order with neat invisibility
triads of triage kept locked in arch i

reremembered memory
resoldered
and here close to the touch
worn wood of a living leg
low to the ceiling
reversal of floor to new formations
four incandescent light fixture campfires
            below three sheer panes
stepping up and through doorframes
ascending staircase fences
careful keeping safe indoors
try i i catch

tectures && within mutating convergent n-manifold fantasies && scenarios
flexible plastic setting profuse repopulating hyperfocus interpersonal saturating layers
an arm through a glass door   september wedding   a thrilling glimpse   rising globe of heat
swimmer drying   shamefaced argument   swollen crusting leg   bitter taste   your voice
whose laughter   fluorescent glare   muffled breathing   soft dirt   dogs barking
propagating recirculating clutter marking slashed delineated pick-cracked seconds
fragmented glancings of food and skin crystals scarcely settling
into plots of infinite books while winding roots twining floor && up walls mirroring
alone outside patches of vegetative tumors gleaming thickly in the starlight
head down in the dark with growing teeming crawling underthings
facefuls of spiderwebs

•  •  •

whirring bank of lights inside
longing for the closeknit comfort of the artificially retained
four unnatural colors   three natural ones
oscillations blend && bloom

[ .unified%20field ]

## SCHOHARIE COUNTY SONNET 1 & 2
Ryan Skrabalak

Something about their slow descent and he is
floating, an array of blades, a blue kite, a man
chopping a thunderstorm from his fingertips, all silver
mysterious uprooted trees. In purple flashes outside
the house, in a blue work shirt, melting
quickly, a jinn, unseen by myself, I imagined being
water, home, then dark sometimes, shouting beyond
me, with the weight of city awake at 3 a.m.,
across that valley, bleached over my bone. Flowers
memory pour out of our mouth, black flower, white
tree, once, a red field. Outside the house, quarter after
two, prismatic visible charged units seem to churn.
O it is decent, Barn Angel. Outside, I sit in the flower-
work, strong like laughter, and nobody knew.

.

Here I am a bird, there I am the tiny curve of fish spine
blurred chrome: stirred through you, a botanical
attack. This slammed into my emotions with glass
and shells, glued together natural disasters and nuclear
clouds, the first undecided flakes to love the dark ground.
Employing the old language, you plant yourself
small, shining on the breathing pink mountains
between my shins, broadcasting what it is like
to want each other when the snow really begins to fall
over the chessboard. We know how to lie, we smoke
long cigarettes wrapped in these soft-boned streets
to your place. It would appear that I am a young boy
with a postcard from your garden. Tonight the stars
confirm that nature. There is really no way I can lose.

## GROUNDWORK
Thomas Devaney

Nothing is impossible near the air ducts.
A sledge hammer in the air, men thinking
            as clear as the day, close
as can be to the hardwood floor, it's
holding nearly all of me up. I can see out
            of the back storm door.
They keep on working: the slab
is much deeper than anyone knew. A long time after,
a man from the neighborhood says he thought
there had been three feet of concrete poured into
that patio years before. Turn every inch of it on over.
Headband tied to sweat-beaded face says,
he'll be out in "the shallows." Men are always
in the backyard now digging. Sparks fly.
Sparks from the men's dusty mouths.
I don't know enough not to listen, or hear the cursing—
I'm swept away from the window, the room stays,
I remain in earshot. A sound of fright: sound of the end.
It's interesting not to remember the body
            when remembering certain days. In the yard
the cement may never end,
            it must. A dozen men will take this one
with them. Twenty men are convinced it can be done.
No one will go home. I am not home, but for the rest
            of my life I live with these men. The cement
has yet to dry. I dream into the cement before it does.
My name is my face on the floor. I only ever wanted out.
A voice says: It's too late. I don't believe that voice anymore.

SITUATION 5
Mary Lum

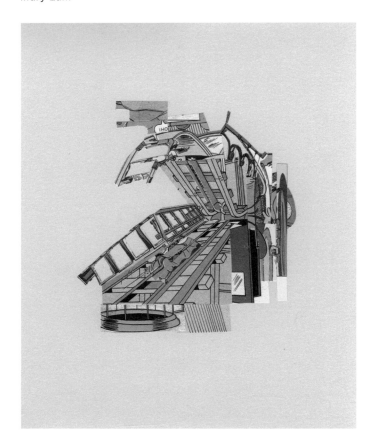

# THESE CRAYONS ARE MEN
Melanie Maria Goodreaux

*little fingers and cobalt blue*
*little fingers and brick red*
*little fingers and maroon*
*little fingers and burnt sienna*

these are not colors
this is not hot wax and the history of Crayola
these crayons are men
strolling along with their wives
walking into office
heading to the library
yipping towards their homes
which are the spines of *Time-Life* books bought by my daddy—one from each decade
bound in a 1970s passion of uplifting stripes and groovy colors.
these crayons are men
living next door to the fat-burgundy-back of the medical book
where a naked man and a naked woman are defined in lines
several floors and doors down from the animal book
with a shocking spider of terror on page 73 (that scares me every time)
these crayons are men
hopping along with their lady friends—
flamingo pink and plum purple
prancing by my brother's football trophy
which is a divinely tall statue of art
in the land of the bookcase on Farragut St.
they talk about dinner and love
they walk their kids to school
a shorter color is a bald-headed man, aqua blue,
more rounded by use in his other karma of coloring hard inside the lines
he is the mayor, a polite crayon to meet and greet on shelf one
standing in front of the King Kong water globe
where I can shake and make it snow
even though it's summer in New Orleans
these crayons are men
and I am their five-year-old puppeteer
the master of their mouths
the maker of all their decisions
I pull them out of a box
I match-make them with honey-brown wives
and yellow-orange girls
that like to get dressed-up and go out on dates
that are further up the mahogany furniture statement

a date that requires a chair
cause I'm too short to fly them there
in this show that is my own while I'm alone

the bookcase was the place to be
for me and my little fingers
apartment buildings of books
the beginning of city living
for an Algiers girl who lived between two wild empty lots of grass and weeds
and puffy flowers with white afros to wish upon from the ditch

the ditch was a place to wish
the ditch was a place to itch
hiding below the mailbox
while watching the global world of ants
carrying the queen of a crumb
from grass to pavement cracks on their red ant backs
busy, busy, *busy*
the ditch was a place to wish
and dream up little girls and a paint job for the abandoned house next door
with its broken windows, and life emptied by blackened summaries of nothing there
filled with scenes from my daydreams of future days to fulfill
and swallow up by time and hopscotch, double-dutch,
and using road-rocks as chalk for the walk
the three wee mahogany girls I prayed for
finally appear in plaits and plaid to play
and I'd stay there all day
morphing into magazine-worthy American blackness
painting my toenails red with Dayle while listening to Anita Baker loud
playing cards in the kitchen, trumping with hearts, slamming down spades
participating in the cinnamon bread loaf of life
the ditch was a place to wish

*little fingers and thistle, flesh, green-blue*
*little fingers and olive-green*
*little fingers caressing time, carnation pink, cornflower, maize*

and a million made-up conversations
playing God and magic-wanding the reality of my forties
the defining moments of dandelion weeds blowing fuzz for the future
baby-knuckles knocking with hope
on raised graves
imagining grandpa and mamere can hear me
from beyond death and the cement wall
where one day my little fingers will lay down
with all the other bones

IT     IS                                    JOY

                        TO

                                    BE

HIDDEN                  BUT

                        DISASTER

            NOT    TO    BE

                                    FOUND.

D. W. Winnicott, COMMUNICATING AND NOT COMMUNICATING

JOY IT IS

TO

BE

HIDDEN BUT

DISASTER

NOT TO BE

FOUND.

D. W. Winnicott, COMMUNICATING AND NOT COMMUNICATING

# TUNNELING
Sarah Dohrmann

I practiced French in my bedroom closet, in the old house where my mother had died. I didn't want my family to hear me trying another language, so I sat inside the sliver of a space that cannot rightly be called a room. I slid the door closed. I held a flashlight in one hand, I held index cards in the other (*la maison*, *le mur*, *la porte*, *la fenêtre*: "*Puis-je fermer la fenêtre?*"). I said the words to myself aloud.

A tunnel appeared in the far corner of the closet. I had tried other tunnels before, but they only traveled just below the ground's surface, making me into a mole. One tunnel stopped as far as my sister's bedroom, which was directly below mine. Another brought me to the backside of Richman Gordman's parking lot, to a line of timber that separated beige suburban homes from beige suburban stores.

I wanted further. I wanted to turn into a frog. I gave myself frog feet and frog legs that could swim in perfect symmetry. When the tunnel appeared, I poked my nose in deep, then pushed hard to where the earth was cold and wet. I looked back to admire my frog legs. I wrote very fine letters on my *machine à écrire* to other frogs like me.

Then I tried Arabic. The earth thickened. It was rich and thick. I put my whole face in it, and it squeezed me in return. It squeezed my slick, rubbery skin. It knew I wasn't a frog. It wanted my essential self. My legs twitched, my gills burned. I was holding my breath, I realized that I had been holding my breath the whole time, then I realized I was the one to blame for holding my breath. It was me who'd come this far. I felt dumb, so I decided to swim further down. Why not see how long I could hold my breath. I had already swum so far from my small closet in the house where my mother had died—so far even the words "small" and "closet" were unfamiliar to me.

Only my heart remained the same. I could hear it beating the whole time, that's how I know. Then, the earth became very dry. There was light there and gray dust, and bones. Human bones and frog bones and dog bones and cat bones and horse bones and mule bones and donkey bones and goat bones. All kinds of bones. It wasn't until I reached these bones that I took in breath. It wasn't until the bones that I could breathe.

# DESERT SHELLS
Amanda Tomme

An ear laid against the parted lips of a queen conch shell will hear the ocean. This was a fact told to me by my California-born mother who raised me on the suburban tales of her 1950s and '60s La Crescenta upbringing. Her recollections were often an account of Southern California beauty braided into alienation. The color of her skin turning in the sun from white to pink to deep red as she lay out on the beach in teen-zealous lathers of cocoa butter was pressed into my mind. The riptide that once nearly drowned her made me forever think twice about what lies beyond knee-deep water. And if it weren't for that dreamy lifeguard who rescued her, holding her fatigued ragdoll body in the anchor of his bicep as he pulled her back to shore, she wouldn't be here.

All near-death stories hold in their breath the aurora of adventure. When she spoke, her voice reached into a place that a child will wait to uncover with nail-biting anticipation—a mother's life before they were born and the suspicion that it somehow still bore happiness and meaning without them. To hold the shell, her ocean relic which sat on our glass coffee table, was to touch the essence of her autonomy, and possibly my own.

My siblings and I grew up in the desert of Las Vegas, but we had been to the ocean a few times in those grade-school years. The salt had stung me, the waves had rushed me and pulled me down with a planetary force and rhythm that made something charming out of being caught, controlled, and then freed again. I had remembered the sound of the ocean—enough to validate for myself that the large seashell in our living room was indeed accessing an authentic portal to the ocean. Its body was an infinite tunnel built of color and texture fit for both flesh and bone, spiraling toward an unseen heart—the point where the ocean could be heard simply existing, impervious to time, pain, or loneliness in the space bowl between continents. That single, static sound seemed to offer up some kind of beautiful promise.

I was born deaf in one ear. I have existed in a perpetual state of mis-understanding what the world is saying around me, and so my responses to people and situations are often made without commit-ment. I nervously await your clarification, the announcement that I misheard wedding for sledding. The wrong acoustics in the room can turn the comedy into a mystery. The directions left for right. When you can't quite hear, you sometimes relate to the world as one does in

a country whose language they are only mostly fluent. I rely on wordless communication: gestures, intuition, the endless collection of human clues, the dreams in between the sure, solid words— the ocean calling from the shell. I held it up to my good ear like a telephone waiting to receive messages that might explain life from my child gaze, while sitting on top of the cinderblock wall in my backyard that faced an empty desert lot full of lizards and caliche rock crowned with the rust and rubble of mysterious metal trash dumped there by strangers and glowing from time to time in the blue light of an Albertson's supermarket sign that towered from across the street.

When I put my one good ear up to the shell, there was nothing grounding me on the other side. Deaf to the outer world, I was swept to the bottom of the ocean where there was peace in the sound of non-sounds. There I could sleep, love, be loved forever in a slime trance, a sparkle trance, a big black rainbow trance, and travel the manifestations of my own unknown heart. It seemed there was no terrible mood that could not be broken by lifting the shell to my good ear. There was no moment of misunderstanding that could not be clarified by the sound of the ocean therein. When I was done listening, I would return the shell to its place on the glass table where I could see underneath to the pea-green carpet and a black and white cat named Panda who liked to play there with a little fake mouse that squeaked when pressed just right.

SARDINES
Brian Blanchfield

Sardines is or was a hiding game that accommodates multiple players and represents a significant improvement on Hide and Seek— or, rather a developmental advancement—as it introduces the social and psychosexual into the foundational game of independence rehearsal whose basic rudiments are absence, reassurance, detection, and self-concealment. The child who experiences in Hide and Seek the rueful pleasure of empathic superimposition ("she will never find me here") is a candidate for Sardines. Sardines builds into the familiar format the stirring new elements of conspiracy, refuge, betrayal, gratification deferral, cultural assimilation, and sustained bodily contact.

One person hides and everyone else, each member of the search party, is It, a party whose number dwindles as, upon discovery of the chosen hiding place, a searcher suppresses any paroxysm of triumph and covertly joins the hidden party, cramming himself silently into the closet or crawlspace, in effect turn-coating his detective affiliation to steal away for safe haven, to become a refugee among refugees. The shared hideout toward the end of a round of Sardines is a squir-ming mass of maximally compressed, clinging bodies in the dark trying not to laugh or breathe audibly until the final discovery is made and the game has its villainous loser, on whom the constriction of frozen postures and half erections and self-estimations and collect-ive suspense outpours and unburdens itself, spilling and showering around him the loud relief—real for some and feigned by others—of unstrung individualities distinct again and reviewing comparatively their dismay. It is a game of early adolescence.

Ordained confinement wherein embrace is organized as a situational necessity is recognizably the ground floor of my erotic imagination. My early fantasies and even dreams were perforce arrangements of closeness with boys, ingenious scenarios that late Cold-War tropes helped to prepare: root cellars during a tornado scare, bomb shelters, prisoners' quarters, deep dry wells, or dens within caves demanded that another haplessly subterranean boy whose form I could barely make out in the pitch black must stand or lie squarely against me. Endless stimulation in the *fort-da* wiggle room between speculation and the highly conditional permission to touch: Does he feel what I feel? and then, We have no choice, we have to be like this. Experience finally suggested that unconscious invention of such imperatives is common within culturally abhorrent sexuality. In the homoerotic

film *Brothers of the Head*, by Lou Pepe and Keith Fulton, the meta-
phor is precisely exteriorized: conjoined twins inseparable at the
torso have grown into young adulthood in early Eighties down-
trodden industrial England and fashion themselves as a punk duo,
shirtless and indignant on stage and with the prurient press,
wrapping their arms around one another, turning from the spotlights
so that the mouth of one is ever whispering distance from the ear
of the other, because (what if, so what) they have to.

"Because we have to" is a construct different from the fresh "because
we can" punch line of sexual liberation. It values freedom differently,
and is implicitly defensive, defensible. The identity-political same-
sex Eighties, backing itself into the corner of legitimacy, begs the
pardon of its ruling fathers by a civil means. It happened within each
body: think of each body listening, at the cultural culmination of
confinement erotics in the Reagan-Thatcher era, the famous double
live album *101* by industrial band Depeche Mode, drenchingly and
reverberantly sinister—replete with sounds of hydraulic releases,
chain pulleys, and vise cranks—when the chamber endgame atmos-
phere is distilled for the ballad "Somebody," which details a fantasy
of complete intimacy with some specular somebody imaginable and
fully other, and which ends, "In a place like this / I'll get away with it."
The rapt crowd is thick, aroused, blandished, sanctioned, beside
themselves before the lickerish bouquet.

CLOSET
Jennifer Firestone

The body is *more* or *less* a body in here.
The body might be with another body in here.
The body of a body is one body on a body.
The foreboding bodies beyond doors.
The body not here but nobody bothers.
Don't bother the bodies that are bothering.
There are all kinds of bodies.
*bodies, bodies.*
Close the doors.
To close, covet, closet, closeting.
Doors to close the closet.
If I close my closet.
What to hang, what to shelve, what to box.
If I close my closet.
A blanket on a rug.
If I close.
A rug with an animal.
We count closet space.
We count.
I count and you count.
We all count.
Close the closet.
Clothes waving.
Anybody entering would hear nothing.
Nobody spoke.
No bodies speaking.
Bodies can quiet without sleeping.
Bodies can nestle, nest.
There is dim light.
There is breath.
Nobody breathing words.
Words in the closet's body.
Closet's hum.
Humans have certain bodies.
And there are other bodies.
She had to hide her body.
Others try to hide their bodies.
Some take our bodies
Some take our space.
She took her own body.
She took her space.

There are shoes.
Dust.
Paper.

A body is a clock.
The closet is the mind.
Traction is the thoughts.
This body sliding close.
This body closing thoughts.

## LOS MOMENTOS MÁS FELICES DE MI NIÑES DESPIERTAN MI TORMENTA, Y MI REFLEJO YA NO SE ESCONDE POR LAS SOMBRAS, HOY MIS PALABRAS NO SE LAS LLEVA EL VIENTO
Joaquin Trujillo

Growing up with lots of family around, my escapes were through my daydreams. I'm the youngest of eleven brothers and sisters, and at thirty-eight years old, I'm still seen as the baby. My upbringing as a child was carefree. Living in such a small, peaceful town, I was able to explore my sensibilities about things surrounding me.

I would walk with my brothers after school to where my dad was working in the fields. On my way, I thought about what it would be like to live in the New York City I knew from photos or what Lucerito (a Mexican singer and actress) was doing at that exact moment. I sang her songs and danced during our walks. No one seemed to pay too much attention to what I did because I was the youngest.

One day, I walked to my cousin's house to find my prima Toña, but not my cousin. She called me by my nickname, Quino, and asked why I was wearing mascara. I told her I wasn't. Toña, sixteen at the time, was the prettiest girl in town. Her mom allowed her to wear mascara and this only enhanced her beauty. She grabbed a tissue, applied some baby oil to it, and wiped my eyelashes. There in the tissue was the mascara. I honestly responded that I had confused the word mascara with eyeliner. I told her I had tried eyeliner, but poked my eye in the process. She smiled.

Hours before I had been in my sisters' room absorbed at their dresser where they kept their make-up. It was a space I sometimes visited. A new world appeared before my eyes whenever I opened their dresser drawer. I wanted to try all the intense colors of eye shadows. But the black eyeliner intrigued me the most.

As a child growing up in Jerez, Mexico, I did things out of the norm. I was surrounded by strong masculine and feminine qualities there and constantly experimenting, subconsciously, with both these sides of myself.

SOÑANDO PARA ESTAR DESPIERTO.
DE LA SERIES NUEVA, DOCE Y TREINTE

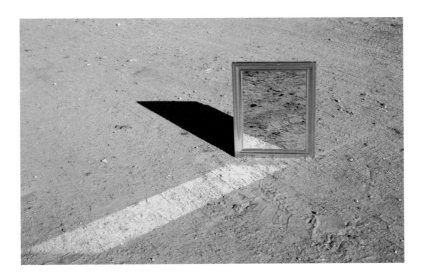

POR QUE FUÉ, POR QUE ES, POR QUE SERÁ.
DE LA SERIES NUEVA, DOCE Y TREINTA

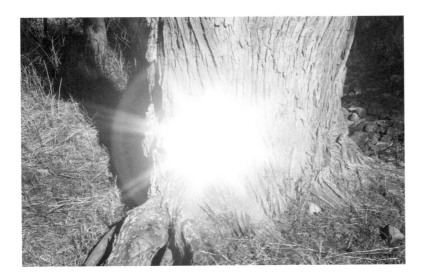

I grew up in a small house. The bedroom my brother and I shared was small. The "toy room" was smaller—large enough for our collection of *Star Wars* figurines but far too tiny for a bed. Our one bathroom was so narrow an adult couldn't spread his arms without brushing the carnation-pink walls. When I was thirteen, I did my part to embody the cliché of American boyhood circa 1985 and laid claim to the lavatory as my site of sexual discovery. In the movies, Mother is always banging on the door, ordering her fledgling tugger to "Hurry up in there," but for the most part my family left me to my explorations in that Pepto-Bismol cave. Whether they knew to what use I was putting the Sears catalogue with its lineup of clean-shaven underwear models and their Ken-doll crotches, I can't say, but I do realize that when I crown this moment, this room, as the dawn of this boy's libido, I'm eclipsing a more fleeting, but perhaps just as fundamental, moment that took place in an even tinier house five years before.

Memory is hazier here, not as reliably buttressed by decades of retelling. The story hasn't been shaped by the streaming repetitions of therapy. The ceaseless flow of cocktail chatter hasn't worn the details down to some round and pocketable thing. The moment still has edges. It's rough, almost forgotten. I'm not sure I'm getting it right. In fact, excepting the writing of this, my mind hasn't turned to the little cardboard house I shared for a summer with Cheryl King for many, many years. It was a birthday gift—or did my Mom order it through the mail?—standing no taller than my eight-year-old self from base of door to peak of roof. Its four walls felt and smelled like a shipping box; but unlike a shipping box, it had character. Characteristics, I should say, that made it homier than home. You've seen this house before. It's a house you'd recognize with the ease of pointing your parents out in a crowd. Precisely cut, fit snugly together with cardboard tongues and slots, a larger version of this miniature house looms large over the American Dream. It is in many ways the ur-house. Two red-shuttered windows with painted daisies in the window boxes, one red front door, bright red fish scales tiling the roof. The only thing missing was the picket fence running round the perimeter, which seemed to do two things equally well: keep you in and others out.

Although I loved shuttling Luke Skywalker around in his X-wing fighter, I was a boy blind to the appeal of the rough and tumble. I didn't want to play baseball or wrestle or race my bike off of damp and sagging

plywood ramps. Mine was an inside voice. I read books. I played school. I was eager that summer for a friend who didn't mind acting a shut-in and found her in the house (guarded by a German Shepherd named—oh, let's just call him Champ) directly behind mine. I'm sure I didn't recognize this at the time, but in retrospect it seems that at least part of Cheryl's appeal had to do with her brother, Kimmer, four years older than the two of us, a lanky, blond boy with a outsized Adam's apple and milky features who, at the ripe age of twelve, stood as a prime example of the male form—as prime as any I'd seen in the flesh—with a more compelling bulge in his swim trunks and tufts of golden hair under his arms. But Kimmer lived in another orbit. His age placed him on the other side of an uncrossable divide. That and something I wouldn't be able to name for years to come but on some level understood even then: if ever he derived pleasure from a Sears catalog, it was from an entirely different section than mine.

In the toy room, Cheryl and I made up games as children do. I used the chalkboard that hung on the paneled wall to teach her and Raggedy Andy how to spell, then the three of us retired to our fairytale cottage as mother, father, and child. Cheryl started by making dinner, two bowls full of pretzels and M&Ms we negotiated from my mother. We discussed whatever news eight-year-olds have to discuss, mimicking the daily banter my parents made as Mom scooped out tuna casserole and passed it around. We put the baby to bed, wrapping him in a velvet blanket the color of canned peas, taking special care to cover his eyes. It was only a matter of time, really, before our clothes came off.

We didn't know what to do or, indeed, that there was anything to be done. We kissed, but, oddly, I can't remember if we touched. I assume we must have, unable to resist the strange provocations our bodies made on each other. It was curious, but being nude set us on a path that invariably led to the same place: we lay down as husband and wife but we got up, quite literally, as country cousins. More speci-fically as Bo and Daisy Duke. I have yet to wind my way through that transformation and arrive at some understanding of the psycho-logical or narrative alchemy that brought us there, to the sexiest (but also, certainly, the most prohibited) duo in Hazzard County, Georgia. I found Bo, with his feathered locks and rakishly unbuttoned shirts, unspeakably appealing. But Daisy was no less captivating with her bare midriff and skimpy denim shorts. I wanted them. In some very real way, I wanted to be them. Both of them. In that little house, I came as close as I think I've ever come to pure, easy desire. Then one day, like a giant climbing down from her beanstalk, my mother

arrived and stomped out the fun. She took our naked fumbling in stride, didn't shout or scold, but she did make us put our clothes back on and promptly sent Cheryl home. I didn't see her again that summer—perhaps my mother had more of an issue with our adventures than I know—and, two months later, by the time school started, Cheryl and I parted ways. She had to repeat third grade. I moved on to fourth, which took me to another building on the other side of town. Of course, we saw each other from time to time. We were neighbors, after all. But now that I'm thinking of her and the flimsy little house that was later crushed, as by a wrecking ball, in a brawl with my brother, I feel a certain sadness—not for a time gone by; who wants to relive his childhood?—but for a feeling. For a comfort in my own skin and all its many wants. For an appetite I didn't have to dismantle or name. For a shelter to call home.

## 44 SYDNEY PLACE
Robert Booras

I remember hiding in the bathroom to touch myself.
I remember hiding under the bed to avoid punishment.
I remember hiding behind the couch anticipating, within earshot,
the discovery of some recent past mischief—a broken glass, say.

I remember hiding in games of hide and seek, cops and robbers,
   and (hush) doctor.
I remember hiding from horror movies my older cousins insisted we watch.
I remember hiding to jump out and frighten my brother,
causing him to fall down the stairs.

I remember hiding to feign running away from home.
I remember its effectiveness as I eavesdropped on my parents' panic.
I remember everyone rushing outdoors to look for me,
the eerie quiet of the house as I stepped out of my hiding spot,

the raised recess of the hallway closet,
my contorted solitude, my reluctance.

## PERFECTION
Betsy Fagin

My closet door is always open. My eight-year-old asked me why and I explained that I like to look at all my beautiful clothes, I find it inspiring: ball gowns, silk dresses, bags and shoes, whatever is currently in season. But I think, at eight, he already knows or at least suspects the truth that closets and wardrobes are magical spaces of potential transformation.

His closet is full of costumes—more costumes than regular clothes (aren't all clothes just costuming?)— Wizard, Twinkie, Clown, Lady Liberty, Construction Worker, Witch, loads of masks, capes, hats, scarves, boas, every accessory imaginable. *Better to be ready than have to get ready,* I tell him. As one of his mothers I get to say sage things like that to him all the time, but I try to not overdo it.

When I was his age, I encouraged/enforced my younger brother and our friends to play a closet game when we visited their house that had a doublewide closet in the room the girls shared. One of us would hide in the closet darkness while the others remade the world, creating an entirely different reality that the closeted person would then have to explore, learn about and adapt to (more *Fantasy Island* than prefigurative politics). It was an always-pleasant social game we all enjoyed. One of the happy episodes with love and tropical adventure—leis and hula skirts—instead of the nightmarish ones where you'd rather change the channel or turn it off.

At home, at eight, my own closet was a small space of about two-and-a-half feet deep and maybe four feet across. Some clothes hung from the rail and there was a shelf above for *Perfection* and *Numbers Up* (games where the fight is against time itself), the horrible china-headed doll a grandmother had given me and the other one with eyes that opened and shut—dolls were never my thing. There were enough clothes hanging to form a canopy, a cover, enough to hide beneath, shelter there. To make it more comfortable I brought in a remnant left over from my grand-mother's house, a bit of pink carpet and a kid-sized wooden rocking chair that I could still fit in comfortably.

I don't need to divulge the details of what makes an eight-year old girl create a safe haven in the darkness of a closet. It wasn't a game.

It wasn't social. I wasn't hiding in hopes of being found. The pain of then doesn't disappear in the darkness or over time. A great deal of suffering stems from our experiences of our lives not being as we'd like them to be—one of the drags of the human condition. As real and predictable as suffering, however, are kindness, compassion, magic and transformation.

Inhabiting my own suffering, varieties of closeting, dragged me toward transformation through the practice of mindfulness. In the traditional practice of loving-kindness meditation, maitri, one of the stages asks that you call to mind someone who loved you unconditionally—always, every time, no matter what. It was challenging for me, painful to feel the lack of it: *wait, what? everybody got that? unconditional? really? was I out the day everybody else got that because...* I don't know about that. Unconditional sounds pretty intense. Loving without wanting anything in return? Without demands or rules or contingencies? Not based on performance or predicted returns? I really don't know about that.

Being a child (also being an adult) was a very dark time until it wasn't. Until I realized in that darkness that some light still gets through. Penetrating even under my clothes canopy, behind the tightly closed door, my self wholly hidden away, ears plugged against the shouting. With eyes adjusted to darkness, darkness grew less dark. Where all seemed consumed in shadow, in fact, there were cracks where light shone through. There was unconditional love and it found me in the oddest way—so queer I didn't even recognize what was happening until many years had passed. My perspective on it is no longer the same. For the longest time I mourned that time, felt so injured by it. I thought I was escaping, hiding, trying to get away from terrible circumstances, but actually it may be that I was preparing, getting ready. That may have been the beginning of the beginning, the initiation. Taking dire circumstance and making myself at home there, comfortable, with softness to rest on, ease and encouraging words from a future self who promised me everything was going to be ok.

*Where is that voice coming from? from nowhere? from through the cracks?* I'd learned early to self-evaluate for sanity, so it's only very recently (last Wednesday) that I would even admit to hearing a voice telling me everything would be okay. It wasn't a voice though, it wasn't sound. It was more essential: the impulse to drag in the carpet, to comfort and soothe with rocking, to tap messages of love and hope through the wall to my younger brother also

hiding in his closet in the room next to mine. It was never a game, but we can pretend that it is.

Let's play a game and let's make it fun. We're having fun right now. And everything is going to be okay. It already is.

IT                          RANGED, TOO,

              VERY

SUBTLY AND                       CURIOUSLY, AMONG

                    ALMOST

       UNKNOWN              OR UNRECORDED

THINGS;    IT LIGHTED ON

                              SMALL THINGS

AND SHOWED THAT PERHAPS THEY

         WERE NOT         SMALL AFTER ALL.

       IT BROUGHT BURIED         THINGS

                    TO LIGHT

AND MADE ONE WONDER WHAT

      NEED THERE HAD BEEN

                       TO BURY THEM.

Virginia Woolf, A ROOM OF ONE'S OWN

IT RANGED, TOO,

VERY

SUBTLY AND CURIOUSLY, AMONG

ALMOST

UNKNOWN OR UNRECORDED

THINGS; IT LIGHTED ON

SMALL THINGS

AND SHOWED THAT PERHAPS THEY

WERE NOT SMALL AFTER ALL.

IT BROUGHT BURIED THINGS

TO LIGHT

AND MADE ONE WONDER WHAT

NEED THERE HAD BEEN

TO BURY THEM.

Virginia Woolf, A ROOM OF ONE'S OWN

BOX 261
Lulu Sylbert

Just as I've wished to unzip a lover's skin and work my way inside until I wore him, crowding him, his seams straining, me warm and contained and un-seeable to the outside world, I wanted, as a child, to stuff myself into those miniature rooms, and pull the wall that didn't exist closed behind me.

I would Alice-in-Wonderland my way in, and then, the perfect size, I would try on the rooms, sampling the beds and chairs and bowls like Goldilocks.

Patience, dexterity, and frugality not among my mother's virtues, her secret purchase of a dollhouse kit, a *kit*, must have been one of impulse. And it must have taken her a while to assemble. All of December, I'd guess, to be ready by Christmas. Wood glue; sander; tweezers; paintbrushes with a countable number of hairs, each paint-stuck to the newspapered floor. Late at night, after I was asleep, when our house was dark and cold and quiet.

She painted every roof-shingle of the white wooden house dove gray, and the shutters dark green; an elegant, old-fashioned house both she and I would have been happy to live in. Dormer windows jutted, symmetric, and doors swung silent on invisible hinges. Over the years, we furnished it at the dollhouse store on Madison Avenue where the salespeople thought they worked at Tiffany's; for my birthday, I'd pick out an exorbitantly-priced telephone, smaller than a bean, or a tiny candelabra made with such devotion to accuracy that a green baize pad lined its base. My mother forbade dollhouse people, so I had stuffed mice. They stood on their hind paws—one wore a green satin Scarlet O'Hara gown; a brown mouse was dressed as a maid, a miniscule organdy cap glued between peaked ears. Their fur was real, and although even then I suspected that the truth was more brutal, I imagined live mice waiting patiently, vocationally, in line, to be relieved of their coats.

As I child, I had favorites, fetishes even: Fabergé eggs, Joseph Cornell boxes, purple and crimson orchids. I longed to be invited in (or back in, I should say). I had a recurring dream that I lived in a maroon velvet palanquin (carried aloft, oddly, by four muscled and shirtless men). There were no windows and the dark red walls were soothing, the fabric as soft as caterpillar. (Even colorblind people are comforted by the color red.) I studied children's books with cross-sectioned molehills and rabbit warrens, tunnels as elaborate as the human ear that led to private pouches of perfect, crowded domesticity (I am an only child). But it was the rooms of the dollhouse that became my place of near completeness. Even though I knew it

belonged to the mice, I lay on the green four-poster bed, and fell asleep gazing at the walls, all three of which were a uniform blue (my real walls were different colors); when I woke, I felt the pink rug beneath my feet (in life, my mother forbade carpet, and pastels). All concentrated childhood play transpires in a form of trance. Transported. But what I felt when I inhabited the dollhouse was calm. It was someone else's home; I was a visitor. Like Goldilocks or Alice, I could borrow the rooms, taking up what wasn't mine for a moment, having left behind whatever I wished, beyond the house's perimeter.

Years later, a decade and a half after the dusty and splintered dollhouse was shipped off to the housekeeper's own daughter in Guatemala (along with some wood glue), when I was living in the woods in love with a drug addict, and thus a drug addict myself, I had a P.O. Box. Back home, in New York, P.O. Boxes were for the hapless, the listless, the peripheral, I thought, the vaguely criminal. Which is what I'd become, even in sunny California. (Wolfie, the hirsute mailman of my childhood, was a force against apathy and entropy— the trustworthy blue, the everydayness of him.) I didn't receive any mail, perhaps because I'd let no one save my mother know the number—261—of the box I'd proudly come to share with my boy-friend, but I'd check anyway (he even gave me a key). I was much, much farther away from home than implied by the literal distance.

Sometimes I imagined myself very small, living with dollhouse furniture in the box numbered 261. A giant hand, like a paw in a mouse hole in an old cartoon, would jut in every so often with the mail, and threaten to squash me. I liked the idea of living in the little aluminum box. I thought of my dollhouse. The one in which I could be tiny and safe. The one in which life was limited, and not up to me.

BOX 261
Lulu Sylbert

DREAM CLOSET

Just as I've wished to unzip a lover's skin and work my way inside
until I wore him, crowding him, his seams straining, me warm and
contained and un-seeable to the outside world, I wanted, as a child,
to stuff myself into those miniature rooms, and pull the wall that
didn't exist closed behind me.

I would Alice-in-Wonderland my way in, and then, the perfect size,
I would try on the rooms, sampling the beds and chairs and bowls
like Goldilocks.

Patience, dexterity, and frugality not among my mother's virtues,
her secret purchase of a dollhouse kit, a *kit*, must have been one
of impulse. And it must have taken her a while to assemble. All of
December, I'd guess, to be ready by Christmas. Wood glue; sander;
tweezers; paintbrushes with a countable number of hairs, each
paint-stuck to the newspapered floor. Late at night, after I was asleep,
when our house was dark and cold and quiet.

She painted every roof-shingle of the white wooden house dove
gray, and the shutters dark green; an elegant, old-fashioned house
both she and I would have been happy to live in. Dormer windows
jutted, symmetric, and doors swung silent on invisible hinges. Over
the years, we furnished it at the dollhouse store on Madison Avenue
where the salespeople thought they worked at Tiffany's; for my
birthday, I'd pick out an exorbitantly-priced telephone, smaller than
a bean, or a tiny candelabra made with such devotion to accuracy that
a green baize pad lined its base. My mother forbade dollhouse people,
so I had stuffed mice. They stood on their hind paws—one wore a
green satin Scarlet O'Hara gown; a brown mouse was dressed as a
maid, a miniscule organdy cap glued between peaked ears. Their fur
was real, and although even then I suspected that the truth was more
brutal, I imagined live mice waiting patiently, vocationally, in line, to
be relieved of their coats.

As I child, I had favorites, fetishes even: Fabergé eggs, Joseph
Cornell boxes, purple and crimson orchids. I longed to be invited in
(or back in, I should say). I had a recurring dream that I lived in a
maroon velvet palanquin (carried aloft, oddly, by four muscled and
shirtless men). There were no windows and the dark red walls were
soothing, the fabric as soft as caterpillar. (Even colorblind people
are comforted by the color red.) I studied children's books with
cross-sectioned molehills and rabbit warrens, tunnels as elaborate
as the human ear that led to private pouches of perfect, crowded
domesticity (I am an only child). But it was the rooms of the dollhouse
that became my place of near completeness. Even though I knew it

belonged to the mice, I lay on the green four-poster bed, and fell asleep gazing at the walls, all three of which were a uniform blue (my real walls were different colors); when I woke, I felt the pink rug beneath my feet (in life, my mother forbade carpet, and pastels). All concentrated childhood play transpires in a form of trance. Transported. But what I felt when I inhabited the dollhouse was calm. It was someone else's home; I was a visitor. Like Goldilocks or Alice, I could borrow the rooms, taking up what wasn't mine for a moment, having left behind whatever I wished, beyond the house's perimeter.

Years later, a decade and a half after the dusty and splintered dollhouse was shipped off to the housekeeper's own daughter in Guatemala (along with some wood glue), when I was living in the woods in love with a drug addict, and thus a drug addict myself, I had a P.O. Box. Back home, in New York, P.O. Boxes were for the hapless, the listless, the peripheral, I thought, the vaguely criminal. Which is what I'd become, even in sunny California. (Wolfie, the hirsute mailman of my childhood, was a force against apathy and entropy— the trustworthy blue, the everydayness of him.) I didn't receive any mail, perhaps because I'd let no one save my mother know the number—261—of the box I'd proudly come to share with my boy-friend, but I'd check anyway (he even gave me a key). I was much, much farther away from home than implied by the literal distance.

Sometimes I imagined myself very small, living with dollhouse furniture in the box numbered 261. A giant hand, like a paw in a mouse hole in an old cartoon, would jut in every so often with the mail, and threaten to squash me. I liked the idea of living in the little aluminum box. I thought of my dollhouse. The one in which I could be tiny and safe. The one in which life was limited, and not up to me.

LIFTOFF
Kris Di Giacomo

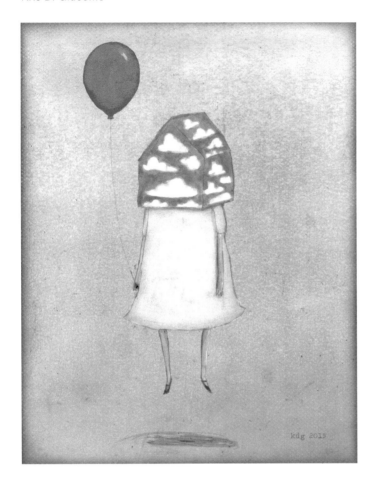

## DEAR WARDROBE
Sal Randolph

Dear
Wardrobe,
out
of
there
smallest
and
suddenly
under
by
the
time
sounding
said
but
dry
rather
handed
round
and
stung
and
everyone
hours
and
hours
and
so
sitting
up
bells
as
without
being
seen
just
outside

MY MOTHER'S **** (WORD I CAN'T TOUCH)
Lara Mimosa Montes

Topaz is a meta-shade
a blessed sort of beige      my mother's cunt
a copper knot was never      the safest place
for me to form me into myself yet I lived there
in love loving her like the softest topaz crayon
I had ever touched      creamy soft inedible
word I can't touch
for fear that to do so would be to jettison all
the bronze soupçons
iotas of myself I had not yet recognized or lost

A FEW WORDS ABOUT MY COLLECTING
David Trinidad

How many Barbie dolls will it take
To soothe your wounds?  How many bubble cuts—
Brunette (your favorite), titian, platinum, ash blonde?
How many ponytails—blonde and brunette?

How many outfits—near mint, pristine, NRFB—
To take away the pain?  How many accessories—
Sunglasses, gloves, necklaces, shoes, gold hoop earrings—
All so very hard to find?  And so expensive—

The pale pink satin gown with long, draping train;
The delicate "Plantation Belle" dress, three tiers
Of frothy lace on tea-length skirt of dotted Swiss sheer—
You can barely bring yourself to handle them,

Though they're yours.  (Well, not until you pay off
Your credit cards.)  Being a poet in New York
Is too disappointing—it's all about politics, not
Good writing or camaraderie—it's too self-serving,

Too cutthroat—you don't want it anymore.  Or
So you tell yourself.  Oh, you still want it—admit it—
You're just not willing to pay the price, not willing
To turn yourself into a monster.  (Or maybe you

Don't have what it takes.)  What you do want
Is your childhood back—every last bit of it—
Every girlish toy you coveted but weren't allowed
To look at—let alone touch—plus everything

You did have that got tossed or lost long ago.
So you collect vintage Barbie—each doll, each outfit,
Each accessory—the way you used to hunt down
Out-of-print poetry books or smoke cigarettes or

Have sex—with the single-minded obsessiveness
Of the truly possessed.  Already you have enough
To fill a small museum—not only with Barbie
But all your secondary collections: Liddle Kiddles

(You're particularly attached to Kiddle Kolognes
—Your sisters had them—thumb-sized dolls in
Plastic perfume bottles, each dressed as the flower
For which she's named—Rosebud, Apple Blossom,

Violet, Honeysuckle, Sweet Pea, Lily of the Valley—
Their artificial scent still redolent after thirty years),
Slickers (Yardley of London's Mod lip gloss in
Those eye-catching—they drove you wild when

You were a teenager—orange-and-pink-striped tubes),
Petite Princess "fantasy furniture" (the blue satin
Chaise lounge—with the gold-trimmed bolster pillow—
Takes you back—Oh, to love miniatures is to kneel

Down like Alice and long for a world you're too big
To fit into), coloring books, boxes of Crayola crayons
(Preferably the 64-pack—with built-in sharpener—
How you love the litany of hues—Raw Umber,

Burnt Sienna, Aquamarine, Sea Green, Carnation
Pink, Magenta, Periwinkle, Thistle, Midnight Blue),
Disneykins (tiny Alice, miniscule Tinker Bell),
Paper dolls, troll dolls, *Classics Illustrated Junior* fairy tale

Comic books (Rapunzel letting down her ladder
Of long golden hair, the twelve princesses descending
A secret staircase to dance till dawn at an underground
Castle, Thumbelina floating downstream in half

A walnut shell), Plasticville buildings (HO scale),
Patty Duke and *Valley of the Dolls* memorabilia,
Board games, Colorforms, lunchboxes and thermoses—
And more.  Dear forty-five-year-old self, I know

How desperately you want to find Lie Detector—
Mattel's 1960 "scientific crime game"—no batteries
Necessary to question twenty-four colorful suspects—
Which you—amateur detective—would do on summer

Afternoons—the Headwaiter's handlebar mustache,
The Night Club Singer's long cigarette holder,
The Gambler's tan complexion, the Actress's flashy
Clothes—savoring each clue.  I know how much

You want Video Village, Milton Bradley's game
Based on the TV show you watched religiously
After school (contestants advanced on a life-sized
Playing board down three streets—Money Street,

Bridge Street, and Magic Mile—collecting cash
And prizes, losing turns, sliding in and out of jail
Through elastic bars, and fishing for wrapped gifts—
This thrilled you—from an arched step-bridge),

And how much you want Barbie's Fashion Shop
And Ideal's Haunted House and all sixteen volumes
Of *The Golden Book Encyclopedia* (your mother bought
A new one every week—at the local supermarket—

Until the set was complete—you'd spend hours
Pouring over the color illustrations) and Aurora's
Plastic monster model kits (you had Dracula
And the Mummy, but always wanted the Bride

Of Frankenstein and—especially—the Witch) and
The April 24, 1964 issue of *Life*—with Richard Burton
As Hamlet on the cover—for the article on trolls—
The phenomenon of the fad—a girl in red leotard

And tights tethered to the ground—like Gulliver—
By an invading army of troll dolls—clouds of red,
Yellow, orange, and white hair sprouting from their
Impish heads (you'll locate the magazine soon

Enough—in a second-hand store in Florida—on
One of your last vacations with Ira).  But locating
The precious object will only slake the ache
For a moment—before desire wakes—yet again—

And overtakes you.  What if you obtain everything
You crave—what precipice will you face then?
A complete collection is a dead collection—or so
Says Susan Sontag.  Oh tortured younger self—

I see you looking for answers in books—searching
For the cause of your conflicts and anxieties—
Your uneasiness with your own appetites.  I see you
Sitting in therapy—week after week—struggling

To come to terms with your "hobby"—with cutthroat
Poets.  Not until you read—years after you move
To Chicago—Emily Dickinson's "I had been hungry,
All the Years"—will you understand that it's better to

Be a person "outside Windows"—as the "Entering"
Only "takes away." Better to leave the playing field
To the monsters (since you don't have what it takes).
Better to refrain—and learn to cultivate—the ache—

DREAM HOUSE (1983 / 2015)
Matthew Sandager

1.

I'm in front of a neighbor's house, wearing a floppy hat adorned with silk flowers; my mother's floral print blouse is piled up on my slight shoulders (the hemline touches the sidewalk); my little feet swim in a pair of her white high heels; a strand of beads drapes around the front of my body. Busy pushing a baby carriage, I stop long enough for this black and white picture. Am I three? My expression: *I was born to care for my young.* Who or what is in the carriage? My baby? Myself? The desktop globe from our brown paneled den? Whatever I believe is in there, one thing is clear: there has never been, never will be, anything more beloved.

2.

It's a Halloween parade in living color. Neighborhood kids mill around the backyard of our ranch house, staring in the direction of the camera: Laurie Merrill, an overweight princess in pink gown (blowing an enormous bubble with her bubblegum), and three unidentified boys dressed as Vaqueros (Mexican cowboys). In the foreground, five of us stand in a line: my older brother dressed as a hobo is at left, my older sister dressed as a nurse is next, Joey Merrill (another bum) at center, then me in a store-bought Raggedy Ann costume, and finally Joe from next door dressed as a cowboy with plastic holster and toy gun. I am wearing a long pigtail wig made out of red yarn, and it even looks as if I have a slash of red lipstick on my mouth. I am squinting in the strong Southern California sun. I am four or five. I am not afraid. I have demanded to wear this costume. Even now, as I stare at the photo, I can hear my brother angrily telling me to get away from him and his friends, that I'm not wanted, to go play with the girls. What I thought was pain is not pain at all, but gratitude: *he's telling me to be my true self.* I am Raggedy Ann. I have a long red wig of yarn. This is pure grace.

3.

Nine years old. It's the end of July, a few days before the first Roadrunners practice—our town's Pop Warner football team. My dad has signed me up for the Gremlin squad. My older brother will be a star on the Mitey-Mite team. There are high expectations. But in this picture, I am standing on our front lawn, just out of the pool. I'm wearing three very large white beach towels: one is wrapped snuggly around my lower body, like a long pencil skirt

that the glamorous Ginger Grant might wear on *Gilligan's Island*; the second is cloaked around my shoulders cape-like, perfectly tied with a long twisted knot, which flows effortlessly down my front side; the third covers my head in a tight, elegant turban. Arms akimbo, cheeks severely sucked in. My naturally long eyelashes, still wet from swimming, look as if they have been plumped with mascara. I am savoring each second of the fading afternoon, ignoring the dread I feel about the impending daily football practices and all things butch. Later, I will ride my bike up and down the block, sitting sidesaddle on the banana seat, waving to droves of imagined admirers in the identical picture windows of neighbors' living rooms.

4.

It's Halloween night. I'm in sixth grade. I am pictured in front of the fireplace in our living room on Landen Street with my mom. She is laughing heartily. I am smiling proudly. I am going as her: I wear her poofy brunette wig, coffee-colored nylons, her short red and blue print polyester dress, and her white cotton sweater over my shoulders (the sleeves dangle at my sides) with only the top button fastened. I have stuffed the dress so that my "breasts" are huge. I wear orange lipstick. I can remember the flash of dread I felt when my dad said, just before I dashed out the front door, "What will your football teammates say when they see you?" I remember that, and also my next thoughts: *It's Halloween. I'm going as Mom. That's the way of it.* I grabbed an empty pillowcase, slipped on high heels, and, completely giddy, hit the street.

5.

The Los Altos Junior High School yearbook photo of me as juvenile fiction writer Julia Cunningham is large and prominently featured among a collage of other candid images of eighth graders. It's a shot of me during a mock interview as part of an English class project. I was supposed to interview the author (to be portrayed by my girlfriend Lisa Casey), illuminate her writing process and describe her body of work. *But wouldn't it*, I remember thinking the night before, *be more interesting if I played Julia and let Lisa be the interviewer?* I wore a long, ash-blonde wig and borrowed a hat that belonged to a friend's mother—one of those weird early '70s crochet caps in avocado green wool, with dozens of flat round silver sequins attached all over. I threw on an old pair of my mom's giant dark sunglasses. And a poncho of some sort. Voilà. Julia Cunningham. I have a broad smile (I'm still a month away from braces). I describe myself to the class as a feminist, though

in reality I have no idea if Julia Cunningham is a feminist—or, for that matter, what a feminist actually is. I just know I feel how women who are identified as feminists on TV look—I'm confident and strong like that. I'm a feminist. And I write books.

IN A TENT IN AN APARTMENT
Margaret Douglas

in this refrigerator box
Chris and Steven Albright
and I would sit
reading Jesus cartoons
and kissing

and in the dog crate
with Peter Churchmouse stories
and *Zoom at Sea*
I'd teach Beezus
quietly to read

and later in my first
apartment with Lucie
I pitched a tent
so I could have privacy
with Flannery

in a tent in an apartment
is so zipped up
not wanting anything
to do with all that
suffocating shit
that could kill us
out there

and I couldn't believe it
last year
when I read Eileen
Myles lost
her lesbian virginity
in a tent in an apartment

because that's me
I did that too
and you are so cool
am I cool too?

but of course I mean
tents are such small safe
spaceships

of course they should
take off with us

sexy astronauts

to the moon and back
then the bathroom
for water

pioneering
the next great sex frontier

at once earthly
and galactic

where at night
I'd hang a flashlight

## THE BAD DREAM CLOSET: AMPHIBIAN ENTERPRIZE
Julian Talamantez Brolaski

I told my therapist Deborah my only recurring dream as a child.
My dream daemon down a dark well. Literally holding my breath in
its claws. The well is narrow and made of a slippery, porous rock, a
mixture between the smooth wet stones of west coast beaches and
the sharp gray lavarock of volcanic islands. Moss and damp. I am
down here, with this creature. It is holding the physical embodiment
of my Breath. Its figure is bent and twisted, with limbs like an
elongated golem. My own physical position is unclear, I am stuck
somewhat below and clinging to the walls of the well, but no
sensation. I can see light several feet up above. I am terrified, can't
move or breathe or scream. There isn't any narrative movement to
the dream, just this hellish state, entrapped in a well with a demon
clutching my breath. I can't remember the exact analysis Deborah
came up with, but it had something to do with me being gay. Gay
and not gay. *À bout du souffle*, the Godard film, is usually translated
*Breathless*, but it's literally "at the end of breath," figuratively "on its
last legs." The word *nightmare*, a horse that runs through the night.
Its first attested meaning in English is in 1300 as "a spirit supposed
to settle on and produce a feeling of suffocation in a sleeping person
or animal" (*OED*). The golem is my mother and not my mother.
Everything is. "You kids are all straight, and you're all gay" the
security guard tells the girls of *Broad City*.

Ken Corbett

In my work as a child analyst, I am often confused, both unwittingly and with intent. Hour-by-hour, I feel myself to be enveloped in a polyphonic field, and I struggle to get my mind into and around the excess. Adding to my confusion, I often court it, indulge it, and mine it to see where it may lead.

I experience this confusion with all of my patients, but it is given particular expression in my work with children, wherein I am often genuinely lost in the potential space of psychic equivalence. I find myself suspended as I am caught in the vista of a child's vision and led toward a *life suspended playing in reality*, playing in a fantastic zone of psychic equivalence, moving as children are wont to move between material reality and psychic reality.

One of the pleasures of working with children is that one gets to work in the land of psychic-equivalence, a liminal space where being hangs suspended between the material and psychic. A spoon is a spoon is a shovel is an evil shovel-monster-man who speaks with an English accent and is set upon devouring the world. Symbols, objects, and characters meld in the alchemy of psychic equivalence. Play is spoken and played with symbols and objects. Characters manifestly take to the field. As the analyst, one speaks within the play sometimes as symbol, sometimes as object, sometimes as character; if you don't speak thus, you are not playing.

When children show up at my office, they are rarely—almost never—looking for someone with a lot to say. They are looking for someone to be done to. One's function as a doer is parsed to the millimeter. Children are looking for someone who can follow them and someone who they occasionally let speak from inside the game about the dynamics at hand. But, most often, my speeches are scripted. In other words, I am almost always told what to say. Too much talking is akin to wind drag. One runs the risk of being a gasbag. And one is promptly told to, "Shut up." Given the squeeze, I often think that my best interventions are monosyllabic: oh, ah, ou, ick, euw, oops, yes, no, wow, ouch.

Working with children has taught me to keep present with the other, where this keeping present has an unexpected relationship to the limits of knowing. I strive to stay one step behind and lean into what I think of as an instructive uncertainty, a mode of unknowing.

As I stumble across the potential spaces I build with children, I try to speak with the characters that pop up there. I attempt to follow their fantastic instructions and to respond in accord with the ways they live between psychic reality and material reality. I work to

decipher the ways in which their internalized object worlds come alive through our fantastically inflected interpersonal experience. I struggle to not only sort out who they are but in what way they wish to be addressed. I look to greet these objects/characters as having an identity of their own and as having the capacity for thinking and feeling that is as real within the liminal world of the game as those of any objects in the outer world.

I enter the field expecting to act and to be acted upon. I expect to construct a network of fantasy and to be pulled into that construction by the patient's internalized world. I try my best to wander. I try my best to be aware of what I have up my sleeve. But mostly, I fail.

SHOULD WE NOT

LOOK FOR THE FIRST TRACES

OF IMAGINATIVE ACTIVITY

AS EARLY        AS IN CHILDHOOD...

MIGHT WE NOT SAY THAT

EVERY CHILD

AT PLAY

BEHAVES LIKE A WRITER,

IN THAT HE CREATES A WORLD OF HIS OWN,

OR RATHER, RE-ARRANGES

THE THINGS OF THIS WORLD

IN A NEW WAY

WHICH PLEASES HIM?

Sigmund Freud, THE CREATIVE WRITER & DAYDREAMING

SHOULD WE NOT

LOOK FOR THE FIRST TRACES

OF IMAGINATIVE ACTIVITY

AS EARLY    AS IN CHILDHOOD...

MIGHT WE NOT SAY THAT

EVERY CHILD

AT PLAY

BEHAVES LIKE A WRITER,

IN THAT HE CREATES A WORLD OF HIS OWN,

OR RATHER, RE-ARRANGES

THE THINGS OF THIS WORLD

IN A NEW WAY

WHICH PLEASES HIM?

Sigmund Freud, THE CREATIVE WRITER & DAYDREAMING

1. It was the fever that got me at seven, when my body shape shifted in the throes of a shivering broil. My elevated temperature lifted me in my expanding room. My body grew to an enormous scale while my arms and legs grew and shrank in direct relation to the room's own changing dimensions. It was then, in the middle of the fever, that I realized all this was in me. I'd already been dreaming up things like this, but the fever set it free.

2. When I was twelve, my family lived in the suburbs of Atlanta. My younger brother and I built a three-level tree fort from three close-together pine trees that were too young to have two-by-fours nailed into them, but we did it anyway. We created a triangular base from the long pieces of wood that we nabbed from one of the many tract housing subdivisions that were blossoming across Gwinnett County in the 1970s. We built upward, three levels in all. We cut out windows from two big sheets of plywood and nailed them to the sides of the triangle base. We hacksawed windows in the first and second floor walls. The top floor was a simple open platform in the shape of a triangle. We used the perch to observe any neighborhood kids who might decide to attack us, which had absolutely no possibility of ever happening. The fact that it had an observation deck, and that the tree fort was inaccessible to adults, made it feel safe from intrusions. The tree fort would almost perfectly accommodate my twelve-year-old body sprawled out from head-to-toe on the second floor, where I loved to feel the tree fort sway as the wind moved the pine trees around.

3. In Atlanta, in every house we lived in, I left messages written in black pen on top of water heaters. I would leave the date and my name as a sign that I'd lived there. I had a nightstand for a few years and I left messages on the bottom of the little drawer that pulled out. There too, I'd write down some fact about myself, what grade I was in, who my teacher was that year, my best friend, how tall I was, how much my I weighed, etc. The night before we left our last house in Atlanta for Iowa, I wrote down some simple facts about my life on a piece of spiral notebook paper: my name, what day it was, and what the weather was like that day. I left the tightly folded note under one of the slats of wood serving as a high shelf in the closet. 5892 O'Hara Drive.

4. In Ottumwa, Iowa, I had a basement bedroom with a drop ceiling covered with chalky gray ceiling tiles, the same ones you'd see in a

drab office. It was possible to lift the tiles and hide my secretly written poems in spiral notebooks up there. It's also where I hid my stolen *Penthouse Forum* magazines, the ones I stole from Target by sticking one down the front of my red, white, and blue running shorts, my favorite pair that summer of 1976. I would bring the magazines home and read those secret, sexy, ridiculous essays with great fervor. I remember thinking that someday someone would find all those poems up in the ceiling and they would be impressed that a fourteen-year-old boy had written so much.

I remember being desperate to learn how to read, hating to have to depend on adults, and knowing that when I could do it by myself, I would be free. I remember understanding a whole sentence for the first time, from a book called *Jim Wins*. After that, there's a three-year gap in what I can recall of my reading bibliography. I was born in Salinas, California, where, for preschool and kindergarten I went to the Montessori school, a stucco building with a tile roof out on Hancock Road. The school was bordered by broccoli and lettuce fields. If we yelled enough at the farm workers they threw vegetables over the high cyclone fence to us. In the playground we snuck into a giant tractor tire to pee. I remember Mark Martell barfing in the garbage can, and a boy sticking a sequin in his eye, pretending it was a contact, but I can't remember any of the books I read to myself until I started to read chapter books, the summer after first grade.

The first chapter book was *The Pentagon Spy*, a Hardy Boys mystery about a stolen antique weather vane. I read most of the book while lying on a deck chair at my grandmother's house on a lake north of Seattle. The book followed the general plot of the rest of the Hardy Boys stories—the dad, the real detective, is away when a client comes in with a case, so the boys volunteer to take it on themselves. Hex signs on barns and other bits of Pennsylvania Dutch iconography play into the plot. Joe, the younger brother, had blond hair, and Frank, brown. The boys were old enough to drive their own car, something called a jalopy, and they had a friend named Chet. *The Pentagon Spy* had the two key elements of the kind of book I would continue to read for the rest of my childhood: the story was set in a place different from what I was used to, and the characters were almost entirely self-reliant.

After *The Pentagon Spy*, I always had at least one book going. My preferred position to read was lying down, ideally on a couch. A bed would do, but I didn't like reading under the covers during the day. The bed had to be neatly made up, lump free. Just guessing here, but I think I liked the feeling of being fully supported, without any of the distractions that discomfort can cause. I wanted to be entirely in the world of the book.

From the hundreds of books I read as a kid, a few stick out, like *My Side of the Mountain* by Jean Craighead George. The main character leaves home to live in the woods by himself—I can't remember why. What I remember is that at one point he gets so malnourished that when he manages to catch a rabbit, he eats its liver raw. I read everything of Madeline L'Engle's I could get my hands on, but I started with *A Wrinkle in Time*. Meg Murry travels through space by way of the fifth

dimension, the tesseract, and she saves her father, imprisoned on another planet. In *The Indian in the Cupboard*, by Lynn Reid Banks, Omri, the main character, puts a toy Indian in an old medicine cabinet, and when he opens the door, the Indian, Little Bear, is alive. Omri's friend Patrick tries the same trick with a toy cowboy. The cowboy and the Indian are both adults, though tiny compared to Patrick and Omri. The cowboy shoots Little Bear, and the rest of the plot unfolds. How is Omri going to make everything right again? The source of the problem—the cupboard—is also the solution.

The cover of a book is the door to the cupboard. The freedom that I imagined as a four-year-old was an unsophisticated freedom: adults can do fun things because they are adults, kids have to follow the rules. But freedom of the cupboard is not binary. Anything can happen.

I read all of Lloyd Alexander's books. From all the thousands of pages I read, only one image remains. In *The Kestrel*, the main character has been so focused on killing people in a war that he loses his mind, only realizing what he's done when he looks down at his hands and sees blood crusted under his fingernails. I was not on a couch when I read that. I had blood under my fingernails, and nobody knew where I'd gone.

## THE FORT
Niki Lederer

Growing up in an unfinished suburb of Vancouver gave me the ultimate opportunity to indulge in tomboy adventures. Our house in the suburbs was built from the ground up, based on a blueprint of catalog designs. It was typical of the contemporary, asymmetrical, A-frame style houses popular in the mid 1980s.

The first prefabricated A-frame that was delivered to the construction site was the wrong size. It sat discarded in the backyard until it became the basis for my backyard fort. My first non-Lego sculpture! It was epic in scale for a ten year old. In the subsequent months of construction that followed, I built my fort on schedule with the house. Each step of the way, I collected the construction discards, two-by-fours, nails, plywood, and even plastic sheeting to create a skylight.

The most distinct memory I have of this time was the crush I developed on one of the roofers. At ten years old, nothing was more heroic to me than someone building a roof with cedar shingles. As the unused cedar shingles dropped into the back yard, I collected them and shingled my own cedar roof onto The Fort. To indulge my growing construction habit, the roofer gave me his roofing hammer at the end of his job. My life as a sculptor began!

I spent a lot of time in The Fort, drawing, building little sculptures, and hiding out from the rain with friends. I loved it.

Collecting discards has always been the key to my sculptural practice. Discarded and found objects are my starting point. I reclaim these materials to create my sculpture, now, specifically, the brightly colored plastic bottles left in curbside recycling that I find while walking my dog. The sheer volume of recyclables creates mountain range after mountain range of empty Tide, Heinz Ketchup, Drano, Mazola Corn Oil, and Tropicana Orange Juice bottles.

I can't resist collecting them and usually go late at night so I don't draw attention to myself. Back in the studio I dissect these bottles, often cutting the plastic with scissors and leaving the edges jagged, fastening them together with wire. The ease of assembly enables spontaneity and lends a playful quality to the work, with some shapes organic and others flat. The sculptures hang from the ceiling with fishing line—light and buoyant, they gently sway as viewers pass by.

# CHEWBACCA
Niki Lederer

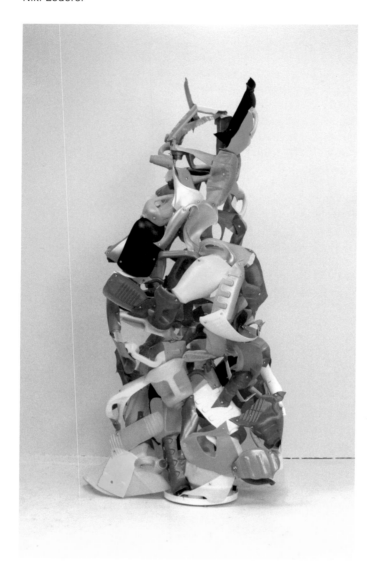

1.

In the early 1990s, when there were frequent mountain lion sightings and occasional mountain lion attacks in the foothills west of Denver, my dad built an elevated platform between four trees on our property, thirty or so yards away from the house.

This platform was just big enough for a tent. It was summertime and my dad encouraged me and my little sister and my little brother to sleep out there. Perhaps we wanted to, but in my memory it was Dad's idea; his delivery to his offspring of the wild childhood he wished he'd had. We were eleven and nine and six. Dad would read us a book by flashlight, and then exit the tent, zip it up, retreat down the ladder and into the house. In the house was our mother, looking out the kitchen window at the half-moon of the tent. In the house was our older sister, profoundly handicapped due to the rare neurological disorder Rett syndrome. Maybe Mom wasn't looking out the kitchen window.

After Dad left was the best time. That was when I could spread my wings out over the other two. I've only ever known the coziness that comes from making others feel cozy.

I don't know if this tent counts as a small space (it was barely big enough for three children and their sleeping bags) or a vast one (beneath the platform the hillside swooped downward to the valley, and beyond the valley, the Rocky Mountains, and above the Rocky Mountains, the universe).

Mountain lions can leap fifteen feet up a tree.

2.

"I've only ever known the coziness that comes from making others feel cozy." I think this is self-aggrandizing. I think this is why motherhood suits me.

I am writing to you from the 38½ week of my second (well, technically, my third) pregnancy. Any day now another human being will crash through me, surge forth from the smallest space into the largest.

3.

Because I was the oldest child in the family who was not disabled, I got to choose my room first when we moved to the house in the foothills west of Denver. I chose the smallest room, the corner one with windows on both sides. My family thought I was crazy.

At the beginning of junior year of college, we drew straws to decide who got to pick her room first. I drew the best straw. I chose the smallest room. My suitemates thought I was crazy.

I am thirty-three years old and I live in a 650-square-foot apartment in Brooklyn with my husband and my daughter and, any moment now, my son. Behind me, his desk nine feet away from mine, my husband apprehensively draws while I apprehensively type.

4.

In my small room in the house in the foothills west of Denver, I insisted on my own miniature Christmas tree. I begged for it when I saw it in its pot of dirt at the supermarket. I decorated it with the lightest, most delicate ornaments I could steal from the ornament collection for the big tree upstairs.

Every night I read a poem. Every night I wrote a poem. Sometimes I flung open the doors of the kingdom. Each Christmas Eve, my little sister and little brother slept in my room. "I've only ever known the..."

I would crawl around the corners of my room, checking for the dead spiders that collected there. I hated the crunch of their bodies in the toilet paper, but I wanted someplace to be perfect.

5.

My daughter wakes too early.

"I hear sirens, Mommy! I hear sirens, Mommy! I hear sirens, Mommy! I hear sirens, Mommy! I hear sirens, Mommy! I hear sirens, Mommy! I hear sirens, Mommy! I hear sirens, Mommy! I hear sirens, Mommy! I hear sirens, Mommy! I see sirens, Mommy!"

I go to her. She stops being scared, I think.

I take off her pajamas and her diaper. We are both naked.

I am so heavy. I get down on my hands and knees. I let my belly hang.

She crawls under me and crouches, though there's almost no room.

"Mommy house!" she cries out, joyous.

I may look like the container, but I am the contained.

# FIRE FROM BENEATH
David Molesky

From a young age I drew my favorite subjects with repetitive force. Some drawings included battles between machines that resembled those I had constructed with Lego sets. I preferred spaceships made with grey Lego blocks and brightly colored transparent add-ons that represented lights and laser beams. Others contained monsters whose bodies and heads were alterations of the letter *c* or *s*. This series might have contributed to the difficulty I had distinguishing between those sounds, and why I needed speech therapy. I drew imagery from memory, or invented it by playing upon each successive mark—like a game of exquisite corpse. I dabbled in photo-based figurative work by drawing many of the action figures depicted in my older brother's baseball cards.

One day, I removed all the coats from the ground floor walk-in-closet. Then I dragged my wooden school desk into the empty space. The desk had a cubby below the seat and a small table surface connected by a wooden arm. The miniaturized version, designed for a toddler, made the snug space seem spacious. I'd pull the long cord, ignite the single light bulb, shut the door, and go to work. I taped finished drawings onto the walls and pulled new paper from the cubby below my seat. I wore a dress shirt and clip tie with a blue blazer affixed with a pilot pin in honor of my grandfather, who flew WW2 supply planes over Burma.

I was terrified of our basement. I would stand at the top of the steps looking into the darkness and proclaim, "There are spooks down there." But intense curiosity gave rise to bravery, and I ventured into the dark caverns. To ensure my safe passage, I studied the furnace, which confronted me with roars and flames. A box in the shadows drew me closer. I rummaged its contents finding an accordion file closed by a string clasp. I had discovered an ancient tomb densely filled with cartoon-like renderings and carried the bundle above ground to investigate its origins. I discovered that my father had made them as a teenager, a surprise because I had never seen him draw.

My older brother strengthened me through relentless teasing and challenges. He asked if I would like a dragon drawing. I said, "Yes!" I wanted to watch him draw it. He refused. When he completed the fantastical rendering he handed it to me. I was at once envious and intrigued; I hungered to make something so beautiful. I begged

him to share his technique, but the denial continued, stoking my desire to master drawing.

In the classroom, a large piece of paper swallowed all of my senses. When I stepped back to see my efforts, I recalled the contexts of my surroundings. I noticed everyone looking over each other's shoulders, collectively drawing the same image and it wasn't what I was doing. My teacher was quick to respond to the building look of terror on my face. She assured me I was actually doing something right.

A few years later, my mother and I came across a He-Man sponsored drawing competition for children in the mall. A group of uniformed organizers handed each participant two sheets of paper. I invented a dragon woman with muscles and a spiky tail that trailed down her spine, combining Wonder Woman sexiness and the shocking otherness found in superhero mutants. Everyone else seemed to be drawing characters that already existed on the He-Man cartoon television show. On the second sheet of paper, I decided to join the conversation and drew my favorite character, Orko, a misfit elf wizard who provided comedic relief around his muscle-bound co-stars. Several weeks later, my mother got a call that my Dragon Woman won the competition and I was awarded a telephone in the shape of a sword. I later heard that Dragon Woman became a character on the show.

When my family was still living in Washington DC—around the time when I created my walk-in-closet studio—I had an auspicious dream. Maybe its intense vividness was brought on by an overdose of Flintstone chewables vitamins. Regardless, it was very real.

We entered what seemed the lobby of a large bank. After a quick exchange with someone behind a large circular desk, we headed left down a hall and down a set of stairs. The underground space was about six times larger than the lobby and was lit only by cages of fire. The cages were square-shaped at the base and extended up to the ceiling. The light was so intense that it allowed only subtle indications of the presence of figures that moved about the flames. Sometimes a shadow would move across a distant wall or a breeze-like flicker of distortion would momentarily eclipse the light. These sensations stirred my curiosity... What were these beings doing here? My mother and I made our way to the staircase that led back to the ground floor. I trailed behind her up the stairs as my smaller legs prohibited me from moving quickly. I noticed some of the people who were among the caged fire had followed me. It was clear from

their body language that they wanted to meet me, and were maybe slightly concerned that the opportunity was passing.

Just before I reached the top of the stairs, they intercepted me. Somehow, they knew I really like applesauce and offered me some. I gladly ate the delicious mashed apples out of the bowl they provided me. However, I lost track of my mother. I thanked my new acquaintances and headed to the lobby in search of her. But she had left. She forgot about me. I went up to a man who I took to be a police officer and told him my name and asked if he could help me get home. I was driven home not in a police car but a red convertible. When I arrived home, it wasn't a big deal. I curled up on the couch for a nap. When I woke up, I was in the same place where I fell asleep in my dream.

FIRST STUDIO (CIRCA 1981)
David Molesky

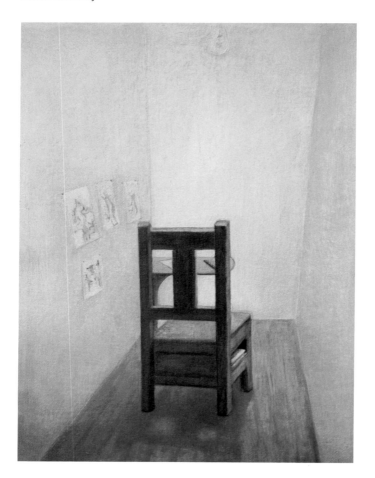

## HUDSON RIVER SCHOOL
Nancy K. Miller

I grew up on the Upper West Side of Manhattan in an apartment that offered slightly angled views of the Hudson River. The layout, known as an "Edwardian Five," was ideally suited for a couple with pretentions to glamour, but no children: a master bedroom, a living room, a formal dining room, a maid's room (for live-in servant), and an eat-in kitchen. During the postwar forties most families converted the dining room to a bedroom for the kids, and the maid's room into a dinette (that was the term). By the time we moved into the building, I existed, and the dining room/bedroom was mine, mine alone until the birth of my sister.

My four-poster maple bed, topped with the classic acorn ornamentation, was adjacent to the windows and from my bed I could see the lights emanating from Palisades Amusement Park across the river in New Jersey. I could read the illuminated news feed that wrapped around the cliffs of the Palisades. I especially loved following baseball scores from the night games we were forbidden to listen to on the radio when we were supposed to be sleeping.

To punish my sister for invading my space, I would regularly narrate the exploits of a dangerous sea monster emerging from the river (the Hudson is an estuary, I had learned in school, so plausible). The Loch Ness monster (no less) was moving, coming closer and closer, I would hiss, describing his hideous advance toward our building. "I can see his shadow, he's almost to the window." By this time my sister was screaming for Daddy. It worked every time. Naturally, I denied all responsibility for my storytelling.

For the cover of *But Enough About Me,* a book about autobiographical criticism, I chose a snapshot of me whispering into the ear of my sister. We are both holding playing cards and my sister's face wears the wide-eyed look of someone who can't quite believe what she is hearing, but keeps listening anyway. I violently wished my sister out of existence, I'm told, but she must have been important to me as my first audience.

I took this photograph shortly before my father's death, looking out the kitchen window at the river on a cold winter day. The George Washington Bridge still beckons, but the park has long since been replaced by real estate developments; the mysterious darkness of the Palisades is no more.

# HUDSON RIVER SCHOOL
Nancy K. Miller

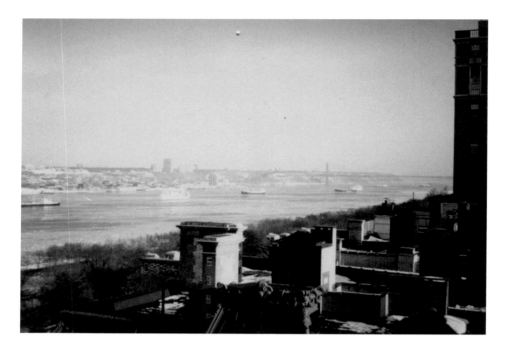

IN PLAY

WE                    MOVE

BELOW

THE LEVEL OF

THE SERIOUS,

AS THE CHILD DOES;

BUT WE CAN ALSO MOVE

ABOVE IT—

IN THE REALM OF

THE BEAUTIFUL

AND THE SACRED.

Johan Huizinga, HOMO LUDENS

IN PLAY WE MOVE BELOW THE LEVEL OF THE SERIOUS, AS THE CHILD DOES; BUT WE CAN ALSO MOVE ABOVE IT—IN THE REALM OF THE BEAUTIFUL AND THE SACRED.

Johan Huizinga, HOMO LUDENS

## PLAY
Christopher Potter

I span around on my own axis in order to spin the world around
on its. I stood on my head and made the world stand on its head.
Somersaulted that the world might somersault.

I jumped into the air. Jumped off the garden shed, and from as high
up the staircase as I dared.

I dug my way to Australia starting out from the Northwest of England.
I wondered where on the way down I should turn upside down so that
I might arrive the right way up. Did I wonder even then whether there
was a right way up?

I climbed trees and towers the better to survey my kingdom. It
was never quite as extensive as I remembered it having been.

I span, jumped, dug, climbed my way out of the world.

If none of this worked there was always magic. I put a blanket over
my head, and in full view of the world, disappeared entirely.

And if none of this worked, I knew there was death—but by then
doubt had crept in. Was death really a way back? And anyway,
where had I come from? I was forgetting. Did I wonder even then
if everything and nothing might not be the same thing?

I was forever in search of something I could not name. Body and spirit
forever wrestling in the space between wanting and not wanting to
be: wanting and not wanting to be here, wanting and not wanting to
be alive. I longed to escape. I longed to be found.

And all of it done as play, laughing.

## THE GAME
Marie Howe

On certain nights, maybe once or twice a year, I'd carry the baby down, and all the kids would come, all nine of us together, and we'd build a town in the basement from boxes and blankets and overturned chairs. Some lived under the pool table, or in the bathroom, or in the boiler room, or in the toy cupboard under the stairs, and you could be a man or a woman, a husband or a wife or child, and we bustled around like a day in the village until one of us turned out the lights, flicking switch after switch, and the people slept.

Our parents were upstairs, with company, or not fighting, and one of us—it was usually a boy—became the Town Crier, and he walked around our little sleeping population and tolled the hours with his voice, and this was the game.

Nine o'clock, and all is well, he'd say, walking like a constable we must have seen in the movies. And what we called an hour passed. Ten o'clock and all is well. And maybe somebody stirred in her sleep or a grown up baby cried and was comforted. Eleven o'clock and all is well. Twelve o'clock. One o'clock. Two o'clock... It went on like that—through the night we made up—until we could pretend that it was morning.

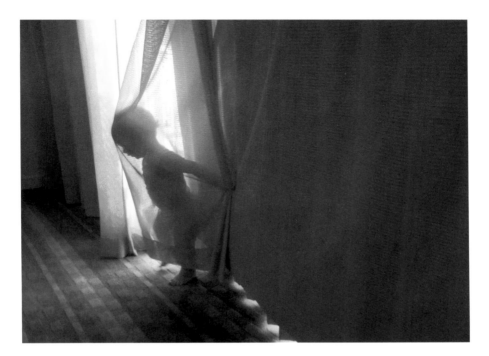

I can't remember what I hoped to accomplish that summer by burying my mother's jewels beneath the floor of our clubhouse, but I do recall feeling a keen sense of purpose as I carried out my plan. Earlier that day, I'd waited patiently for my mother to leave for work. When the coast was clear, I crept into her room, opened the bureau drawer, found her leatherette jewelry case and took what I was looking for—a butterfly spray of blue rhinestones stuck to a lace of faux gold. I folded the butterfly into a handkerchief and replaced the case just as I'd found it.

My mother owned a small collection of glittery costume pieces. She wore them to fancy dinner parties at the Elks Club where my father presided as an Exalted Ruler. When she applied these pieces to her ears or dangled them from her throat, I would literally swoon and turn away. The shimmer of glamour that came off of her in those few moments before she said goodbye for the evening was almost too much for me to bear, like a toxic fume, it got into the depths of me, and reminded me of some deeper and hidden truth— I was different.

As a child, my parents, my sister, and my brother were strangers to me. Even before I knew the word or could articulate my difference, my gayness separated me from them. I was an alien in their midst, a foreigner trying to decipher their native tongue and adopt their natural tendencies. I wanted desperately to break their code without having to give up the thing that made me me.

Technically I couldn't be classified as a thief; I didn't actually steal stuff. I borrowed. Nothing major. A scarf, a comb, a pen, a barrette—I took things from my family members, carried them with me for a day or two, examined them, turned them over in my pocket and then returned them to their original place. No big deal. My hope was that by "owning" their belongings, even for one night, I might catch a whiff of their private selves and gather information about a world they seemed to know first-hand.

The place where I intended to bury the jewels was our clubhouse located down the street and out behind a neighbor's garage. It was a narrow crawlspace protected by a dense thatch of hedge, a place so overlooked that the neighborhood kids and I had been able to transform it into our secret meeting place without anyone's notice or objection. It was there among my peers that I began to feel a sense of belonging, and as a result I quickly went to work. I helped to give the place more of a clubhouse feel by dragging three-legged furniture pieces in from the street, hanging tattered concert posters,

laying linoleum on the dirt floor and artfully arranging a mildewed collection of magazines and books on makeshift shelving. That whole summer, apart from the world of our adult minders, we met secretly to talk business, lounge, and transform our childhood selves into adolescents.

I carefully lifted the patch of linoleum and dug a hole just wide enough to fit my treasure. I then placed the wrapped package into the hole, covered it over with dirt, replaced the flooring, and hurried away from the clubhouse. My plan was to let it sit there overnight and then return to retrieve it the following day.

But the next morning when I showed up at the clubhouse, the jewelry was gone. At first, I figured I'd misjudged the spot, and so I quickly dug another hole nearby. And then another. And then another. Before long I had created a six-foot trench behind the neighbor's garage, but still no box, no jewels, no scrap of hand-kerchief. Nothing.

I went to visit the other kids and asked them one by one if they'd found anything buried beneath the floor of our clubhouse. The look of confusion on their faces was so pronounced I knew they could not be the culprits. *"But why?"* each of them asked me. *"Why'd you bury it? I don't get it?"* What could I tell them? How could I explain? But then, perhaps if we were able to find words for all our actions, we wouldn't need to move a muscle or get out of bed. Sometimes our bodies take us where we need to go—and this is especially true of children.

For the next few days I lived in a state in which all my senses were sharply focused on my mother. Every time she entered the room, I stopped breathing. Whenever I heard the top drawer of her bureau open my heart plunged into my stomach and I swallowed hard. I sweated. I prayed. Weeks passed, months, and strangely the missing jewel never surfaced and it was never mentioned. I returned to the clubhouse again and again, I kicked the ground with my sneaker, sifted through the dirt and yet nothing ever turned up. I began to wonder if I'd imagined the incident or perhaps I'd appropriated it from a fairy tale by Hans Christian Anderson or the Brothers Grimm.

By September our clubhouse was dismantled. One day in late August we found all our secret belongings, books and files and posters, sitting in a pile at the curb and ready for the trash man. The entrance to the crawlspace had been boarded up, and though I didn't know it then, it was to be our last clubhouse. Once school began, we began to form new alliances, our bodies began to take us all in different directions, and mysteries of a higher order began to demand our attention.

Years later, when I learned how butterflies actually get made, I couldn't help thinking about my clubhouse and that long lost butterfly pin. Once inside the chrysalis, the caterpillar slowly disintegrates, dissolves into a soupy mess and disappears. All that remains of him is something called *the imaginal cells;* and out of these very elemental and essential cells, a butterfly is born.

MEMORY
Nicole Callihan

my carnival star mother
not bearded or with fire

but with the strength
of a thousand men

me near the third ring
clapping my two hands

what if she didn't make it
what if I was left alone

a hairpin in a tin
peanut of a heart

cotton candy brains
the crowd waited

we tongued
our popcorn teeth

waited as if for spring
what if she failed

how miserable
we would be

to witness
her demise

but she was fine
totally fine

terribly fine
we erupted

the tent in flames
the bears began

their forgotten jig

People prize what they do not understand.
"Strange music. Disjointed voices."

He was an object of ironic scrutiny, wry self-amusement, especially
when he considered his habit of scurrying for cover whenever the light
shone upon him. As it searched all the shadowy crannies & crevices,
he cowered at the heart of his hiddenness, a black star.

Down in flames, up in smoke.
All are reborn in the fire.

•

Here are the stories grandmother told me out of the Russian night: the
straw man riding a horse on fire, the fool drinking the moon in a cup.

Ulan Bator. A horsehead fiddle. Underbowing. A voice that travels from
hilltop to hilltop under a turquoise sky.

Silvery tinkle of a mandolin.

•

What are these wishful images in the mirror?
Return to a place you've never been?
Hay for the winged horses?

Meno... Nemo... Omen... Omens...
Show me your face before your parents were born.

Yes, there is another world (but it is inside this one).

•

"I long ago lost a hound, a bay horse, and a turtle dove, and am still on
their trail. Many are the travelers I have spoken to concerning them,
describing their tracks and what calls they answered to. I have met one
or two who had heard the hound, and the tramp of the horse, and even
seen the dove disappear behind a cloud, and they seemed as anxious to
recover them as if they had lost them themselves."
                                                    —Thoreau, *Walden*

So a dove disappears behind a cloud, a jellyfish hides in its own transparence, a squid jets away in the shadow-body of its own ink. Yes, mountains are hidden in mountains, moonlight on the tips of ten thousand grasses. Like a child playing *fort-da*, hide-'n'-seek, we know it is a joy to be hidden, but a disaster not to be found.

A mountain floats like a mote in the eye of the sky.

## SO SPAKE THE BUTTLERFLY
Peter G. Earle

The stars will decide when and if
I'll return to this sun-kissed land

But that's not a human concern
or anything that earthworms
in their noontime loam

           are worried about.

I've danced in your garden
and lent you light.

Motion is what counts,
not the duration

my festival of flips
        and waltzes in the sun,

these silent notes unheard
but easily seen
with leaps and illuminations
clearly written on the air,

Is my crazed flight of hiccups
the figment or whim
of giggling gods?
or is it a concession
to the soft summer air?

When I was a girl, I used to lay on the scruffy green carpet in my bedroom and daydream of an afternoon spent in New York City sprawled on an eiderdown in the loft of Jasper Johns and Robert Rauschenberg, listening to record after record of Edith Piaf and Billie Holiday and jazz so cluttered I could only close my eyes to the flood of it filling my veins. In the dream, I was myself, a twelve-year-old kid, but this was my life, this was my Sunday afternoon. The life I knew in my imagination, where my auntie, Louise Nevelson, would drop by to cluck at my latest work and *tsk tsk* my messy sink. I can still feel her hands, cold on my cheeks, and she peered into my eyes as if they were two blue gypsy orbs of fortune and told me where to take my next paintings.

*Forty*, I'd sigh, kicking my Keds in the dust of the playground, *I can't wait to be forty...* At forty I imagined I'd have a grip on life, be a successful artist, have financial freedom. I could see myself all grown up, like Georgia O'Keeffe on Ghost Ranch, focused on my painting. The stark landscape of New Mexico out my window like a blank canvas, and a closet full of androgynous black dresses.

I knew somehow I'd have lovers. Men. Women. I'd never marry. Sex and romance were not on my radar (I wouldn't even kiss a boy 'til I was fifteen), but I was intrigued by the power they held. To be wanted. To desire someone. I could see myself all dressed up in a parlor where Frida Kahlo is holding court with Marlene Dietrich look-alikes.

Somewhere in the blue skies of our minds our daydreams float like sheep in a Chagall painting. As a kid, mine stayed way high up in the front, obscuring my view of reality.

I had read about the artist colony at Black Mountain, and I was convinced that if I could just get myself there I could find my way into the laps of my favorite artists. It was only a five-hour drive from where I lived, and I begged my mother to send me to camp there. I could see myself wandering away from a lake filled with splashing children and climbing over a hill to the artist colony where I would be taken in as a foundling and set up in the extra bedroom across the hall from Franz Kline.

The artist colony at Black Mountain only existed between the 1930s and 1960s. When I was growing up in the 1980s, I believed that it was all happening so close and just out of reach and I was missing it. I spent that summer at home, in the air-conditioned pretend art studio of my bedroom, filling my sketchbooks with colored pencil drawings of my hands: my hands in sets of four with Warhol colors,

my hands signing the word STAY, my hands with fingers growing into paintbrushes, my hands in a peace sign and barbed wire, my hands becoming wings, becoming birds, flying away.

POCKET
Megan Buchanan

And I'm here again
hanging out in the pocket
of God's favorite shirt

In worn blue flannel
filtered light and sound
I'm suspended
along for the ride

Tag-along, tiny human
I am held and warm
horizontal against heartbeats
I can't see the sky

WAITING FOR A SHUDDER
Bill Kelly

Rising on a rocky edge
Too damaged to launch away
Glass eyes still—no sight—nothing
Left. Observed, it seems, between
Language and a camera
This portrait of a nature
Photographer, posing in
A covert, hidden from all
But himself, waiting to see.

History has failed my rhyme
If I could look up, longing
But my light wings are uncarved
Look down another vision
Missed—no truth to trust—no myth
Or memory to jostle
Away this doubt. And yet here
This palace in the kind weeds,
Hidden within my view,
The rushes, where I have heard

Messiaen's birdsong, Walser's
Whisper, whose secret almost
Disappeared, and Celan's echo,
Floating from across the way,
Those heart-woods shaping my slant.
A child/bird of wood, image
Shot with shadow, but felt as
Sunlight. I have seen it all
Sitting, shuddering, here on
The edge of reverie pond.

03:45, 1°09'29"N 86°55'12"W, 3.5 KNOTS WSW. WATCH ALMOST
OVER AND NOT MUCH HAPPENING. STILL NO WIND, MOTOR
SAILING ALONG, SOME LIGHTS OFF TO PORT BUT FAR AWAY.
WE'LL LIKELY CROSS THE EQUATOR SOMETIME TOMORROW
AFTERNOON AT THIS RATE. PISTACHIOS.

Libby Pratt

So many people have to say yes for a book like this to come together. Thanks to Libby Pratt and Michi Jigarjian of Secretary Press for saying yes first, and then again and again throughout the process. Your hard work and let's-make-it-happen attitude have made *Dream Closet* a reality. Thanks to Liz Seibert and Leigh Mignogna for unraveling the layers of the manuscript, exploring them so attentively, and then dreaming up the ingenious design. Your presence can be felt on every page and in every moment you've planted. I also want to thank Ryan Skrabalak for reading the drafts; Brian Blanchfield, Aram Jibilian, Emily Moore, Sarah Dohrmann, and Nancy K. Miller for your generous feedback; and Reza Memari for letting me carpet your apartment with the manuscript. To the contributors, my profound gratitude and amazement.

The title of this collection comes from Denton Welch's autobiographical novel *In Youth Is Pleasure*. Orvil Pym, a fifteen year-old boy, locks himself into a bathroom and imaginatively transforms it into a "tiny hermitage encrusted with precious stones." He constructs an elaborate mental list of jewels in order to "furnish the most intricate details for his fantastically rich dream closet." Welch is an extraordinary poet of miniatures and small spaces, and his work deserves greater attention.

Finally, this book is inspired by an abiding appreciation for the imaginations of children, both the children we were and the young people we encounter in our daily lives. The works in *Dream Closet* testify to the importance of "space" in the ongoing process of our development, and so implicit within these pages is a call to protect, respect, make or co-create these spaces for and with children.

## L. S. ASEKOFF

L. S. Asekoff has published four books of poems, most recently *The Gate of Horn* (2010) and *Freedom Hill* (2011) with TriQuarterly. He received a Witter Bynner Fellowship in 2012, a Guggenheim Fellowship in 2013.

## BRETT BELL

Brett Bell lives and works in Missouri. He has a Masters in photography from Parsons School of Design, and he is currently working on several photographic projects. His first full volume of photography, *Simple Pleasures*, was published in 2011.

## BRIAN BLANCHFIELD

Brian Blanchfield is the author of two books of poetry, *Not Even Then* and *A Several World*, and the recipient of the 2014 James Laughlin Award from the Academy of American Poets and a 2015–2016 Howard Foundation fellowship. His book of essays, provisionally titled *Proxies*, part cultural studies and part dicey autobiography, is forthcoming from Nightboat Books in 2016. He lives in Tucson with his partner, the poet John Myers.

## ROBERT BOORAS

Robert Booras has a BA from University of Michigan, and a MFA from Brooklyn College. He is co-founder and co-director of UpSet Press. He lives and works in NYC.

## JULIAN TALAMANTEZ BROLASKI

Julian Talamantez Brolaski is the author of *Advice for Lovers* (City Lights, 2012), *gowanus atropolis* (Ugly Duckling Presse, 2011), and co-editor of *NO GENDER: Reflections on the Life & Work of kari edwards* (Litmus Press / Belladonna Books, 2009). Julian lives in San Francisco, and is the lead singer and rhythm guitar player in the country band The Western Skyline (www.reverbnation.com/thewesternskyline).

## MEGAN BUCHANAN

Megan Buchanan is a poet, performer and dancemaker. Her poems have appeared in *The Sun Magazine*, *make/shift*, *The San Pedro River Review*, *lines+stars*, and an anthology called *Eating Her Wedding Dress* from Ragged Sky Press (Princeton). Born in Newport Beach, California, she currently lives in southern Vermont with her two children and works as a high school humanities teacher with teen mothers. www.meganbuchanan.net

## NICOLE CALLIHAN

Nicole Callihan writes poems, stories, and essays. Her work has appeared in, among others, *The L Magazine*, *Cream City Review*, *Forklift, Ohio*, *Painted Bride Quarterly*, and as a Poem-a-Day selection from the Academy of American Poets. Her books include *SuperLoop*, a collection of poems published by Sock Monkey Press in early 2014 and *A Study in Spring*, a chapbook which she co-wrote with Zoe Ryder White that is forthcoming from Rabbit Catastrophe Press. Nicole teaches at New York University and lives in Brooklyn with her husband and daughters.

## JEFFERY CONWAY

Jeffery Conway's most recent book is *Showgirls: The Movie in Sestinas* (BlazeVox [books], 2014). He is also the author of *The Album That Changed My Life* (Cold Calm Press, 2006), as well as *Phoebe 2002: An Essay in Verse* (Turtle Point Press, 2003)

and *Chain Chain Chain* (Ignition Books, 2000). His work is featured in *Rabbit Ears: The First Anthology of Poetry about TV* (New York Quarterly Books, 2015). He is currently at work on a collaborative mock epic (with poets Gillian McCain and David Trinidad) about the 1967 film *Valley of the Dolls*.

## TODD COLBY

Todd Colby has published six books of poetry. His latest book, *Splash State*, was published by The Song Cave in 2014. He lives in Brooklyn, New York.

## KEN CORBETT

Ken Corbett is an assistant professor at the New York University postdoctoral program in Psychotherapy and Psychoanalysis. He is the author of *Boyhoods* (Yale University Press, 2009) and *A Murder Over a Girl* (Henry Holt, forthcoming in 2016). He maintains a private practice in New York City.

## MICHAEL CUNNINGHAM

Michael Cunningham is the author of seven books, including *The Hours, By Nightfall, The Snow Queen,* and A *Wild Swan*, which will be published in November of 2015. He teaches at Yale University.

## THOMAS DEVANEY

Thomas Devaney is the author of *Runaway Goat Cart* (Hanging Loose, 2015), *Calamity Jane* (Furniture Press, 2014), and *The Picture that Remains* (The Print Center, 2014). Devaney is the 2104 recipient of a Pew Fellowship in the Arts. He teaches at Haverford College.

## KRIS DI GIACOMO

When I am not making pictures or drinking coffee or frolicking in the concrete jungle or daydreaming, I am grooming my antennae to reach out into the world around me. I also like ice cream very much and I ride a bicycle.

## SARAH DOHRMANN

Sarah Dohrmann is a prose writer of essays, creative nonfiction, and fiction, and a sometime poet. Her work has appeared or is forthcoming in *Harper's*, *Tin House*, *n+1*, *The Iowa Review*, and elsewhere. She is at work on her first book, which is a memoir. You can read more about Sarah at www.sarahdohrmann.com.

## MARGARET DOUGLAS

Margaret Douglas is a poet, playwright, and fiction writer currently studying at Brooklyn College. Selected as 2015 Rosen Fellow, Douglas is now experimenting with motion and poetry while hiking sections of the Appalachian Trail and exploring the great wilderness areas of New England. Having grown up in New Hampshire, Douglas is an avid outdoorswoman and tent connoisseur. She now lives as close to Prospect Park as absurd rent costs will allow with her dog, Little Paw, and her cat, Guillermo.

## PETER G. EARLE

Professor Emeritus of the University of Pennsylvania, Peter G. Earle previously taught at Princeton and Wesleyan Universities. His undergraduate studies were at Columbia University and Mexico City College, and his PhD is from the University of Kansas. He was Associate Editor of *Hispanic Review* for many years and is currently Advisory Editor for the *Revista Hispanica Moderna*. He is author of *Unamuno* and *English Literature* (1960), *Prophet in the Wilderness: The Works of Ezequiel Martinez Estrada* (1971), and

co-author of *Historia del ensayo hispanoamericano* (1973); editor of a critical edition *Garcia Marquez* (1981); and translator of works by Samuel Ramos, Josefina Vicens, and Demetrio Aguilar Malta.

## BETSY FAGIN

Betsy Fagin is the author of *All is not yet lost* (Belladonna, 2015) and *Names Disguised* (Make Now Press, 2014) as well as a number of chapbooks. She received degrees in literature and creative writing from Vassar College and Brooklyn College and completed her MLS degree in Information Studies at the University of Maryland where she was an American Library Association Spectrum Scholar.

## MELISSA FEBOS

Melissa Febos is the author of the memoir, *Whip Smart*. Her work has appeared in *The Kenyon Review*, *Prairie Schooner*, *Glamour, Post Road*, *Salon*, *New York Times*, *Dissent*, *Bitch Magazine*, and elsewhere. Her essays have won prizes from *Prairie Schooner*, *Story Quarterly*, and *The Center for Women Writers*, and she is the recipient of fellowships from Bread Loaf, Virginia Center for Creative Arts, Vermont Studio Center, The Barbara Deming Memorial Fund, Lower Manhattan Cultural Council, and The MacDowell Colony. She is Assistant Professor of Creative Writing at Monmouth University, MFA faculty at the Institute of American Indian Arts (IAIA), and serves on the Executive Board of VIDA: Women in Literary Arts.

## JENNIFER FIRESTONE

Jennifer Firestone is an Assistant Professor of Literary Studies at Eugene Lang College (The New School). Her books include *Flashes* (Shearsman Books), *Holiday* (Shearsman Books), *Waves* (Portable Press at Yo-Yo Labs), *from Flashes and snapshot* (Sona Books) and *Fanimaly* (Dusie Kollektiv). Firestone co-edited (with Dana Teen Lomax) *Letters To Poets: Conversations about Poetics, Politics and Community* (Saturnalia Books). She has work anthologized in K*indergarde: Avant-Garde Poems, Plays, Songs, & Stories for Children* and *Building is a Process / Light is an Element: essays and excursions for Myung Mi Kim*. She won Marsh Hawk Press's Robert Creeley Memorial Prize in 2014. Firestone is a member of the Belladonna* Collaborative, a feminist poetry collective and event series.

## JOANNA FUHRMAN

Joanna Fuhrman is the author of five books of poetry, most recently *The Year of Yellow Butterflies* (Hanging Loose Press 2015) and *Pageant* (Alice James Books 2009). She teaches poetry writing at Rutgers University, in private workshops, and through Teachers & Writers Collaborative and Poets House. She's working on a book-length poetry/photography/sculpture project with the artist Toni Simon.

## MELANIE MARIA GOODREAUX

Melanie Maria Goodreaux is a poet, playwright, and fiction writer from New Orleans, LA. She has been mentored as a writer for over twenty years by such greats as Anthony Saralegui and Steve Cannon, and is a part of Cannon's literary movement and publication, *The Gathering of the Tribes* as well as a featured poet and playwright at the Nuyorican Poets Cafe. Her plays, *Saydee* and D*eelores, Katrina Who?!*, and *Walter, Bullets, and Binoculars* were featured Howl Festival events and have been produced in several theaters from New York City to Los Angeles. She works as a teaching artist for Urban Arts Partnership, Whitebird

Productions, Creative Theatrics and Teachers & Writers Collaborative, for whom she adapted the words of hundreds of New York City children into one poem called "A Poem As Big As New York City," which was published by Rizzoli and Universes, and was a finalist for the 2012 ForeWord Reviews Book of the Year Award for Picture Books (Children's). She lives in Harlem with her husband.

## LIZ FISCHER GREENHILL

Liz Fischer Greenhill is a writer, visual artist, and acupuncturist. Her writing has been published in *The Rumpus*, *Gertrude Press*, *Nailed Magazine*, the poetry anthology *Step Lightly*, and *The Untold Gaze*, a book of writing paired with the paintings of Stephen O'Donnell. Her drawings and paintings have exhibited in group shows and her animated 16 mm short, The Loveseat, traveled in LGBTQ film festivals across the U.S. and Canada. Liz lives in Portland, Oregon with her son.

## CHRISTINE HAMM

Christine Hamm has a PhD in American Poetics, and is a former poetry editor for *Ping*Pong*. She won the MiPoesias First Annual Chapbook Competition with her manuscript, *Children Having Trouble with Meat*. Her poetry has been published in *Orbis*, *Pebble Lake Review*, *Lodestar Quarterly*, *Poetry Midwest*, *Rattle*, *Dark Sky*, and many others. She has been nominated five times for a Pushcart Prize, and she teaches English at Pace. Echo Park, her third book of poems, came out from Blazevox in 2011. *The New Orleans Review* published Christine's latest chapbook, *A is for Absence*, in the fall of 2014, and nominated her work for a Pushcart.

## IAN HATCHER

Ian Hatcher is a writer, programmer, and sound artist living in NYC. He is the author of *Prosthesis* (Poor Claudia 2015), *The All-New* (Anomalous 2015), and, with Amaranth Borsuk and Kate Durbin, co-creator of *Abra*, a conjoined artist's book and iOS app supported by the Center for Book and Paper Arts (Columbia College Chicago). ianhatcher.net

## DAVID HOPSON

David Hopson earned his MFA in fiction from Columbia University. His first novel, *All the Lasting Things*, is due out in February 2016. He lives in Brooklyn.

## MARIE HOWE

Marie Howe is the author of three books of poetry, most recently *The Kingdom of Ordinary Time* (W.W. Norton). She teaches at Sarah Lawrence College and is NY State Poet from 2012 to present.

## LUIS JARAMILLO

Luis Jaramillo is the author of *The Doctor's Wife*, winner of the Dzanc Books Short Story Collection Contest, an Oprah Book of the Week, and one of NPR's Best Books of 2012. His work has also appeared in *Tin House Magazine*, *Open City*, *H.O.W. Journal*, and the *Chattahoochee Review*, among other publications. He is the director of the Creative Writing Program at The New School, where he teaches fiction and is the co-editor of *The Inquisitive Eater: New School Food*.

## ARAM JIBILIAN

Aram Jibilian moved to New York City from his home state of California in 1998 to pursue a Master of Arts in photography at New York University. This past year, Jibilian was invited to participate in the 2015

Venice Biennale as part of the Republic of Armenia Pavilion on the island of San Lazzaro. The exhibition, entitled *Armenity*, captured the Golden Lion Award for Best National Participation. In addition to his art practice, Jibilian recently completed his Master of Social Work degree at Hunter College and currently works as a therapist for youth experiencing homelessness in New York City.

## MICHI JIGARJIAN
Michi Jigarjian is a visual artist living in New York City. She is a co-founder of Secretary Press and New Draft Collective and received her MFA from ICP-Bard. Jigarjian's work has been exhibited internationally and she is a 2013 recipient of the Lower Manhattan Cultural Council's Swing Space Residency. Michi is the President of Baxter St at CCNY since 2012 and teaches in the ICP-Bard MFA Program.

## BILL KELLY
Bill Kelly is an artist and writer, as well as founder of Brighton Press—an internationally known fine press artists' book publisher that he started in 1985. His authored books include *Force = Equal*, *Mimages*, and *Duck Blind*. His artwork is housed in numerous collections, including the Achenbach Foundation for the Graphic Arts in San Francisco, the Getty Research Institute in Los Angeles, the Walker Art Museum in Minneapolis, and the Toledo Art Museum in Ohio. Kelly was awarded a Pollock Krasner Foundation Grant in 2002. He teaches in the Art Department at the University of San Diego.

## WAYNE KOESTENBAUM
Wayne Koestenbaum—poet, critic, artist— has published seventeen books, including *The Pink Trance Notebooks*, *Jackie Under My Skin*, *Andy Warhol*, *Hotel Theory*, *Humiliation*, *Best-Selling Jewish Porn Films*, *The Anatomy of Harpo Marx*, *My 1980s & Other Essays,* and *The Queen's Throat* (a National Book Critics Circle Award finalist). His first solo exhibition of paintings took place at White Columns gallery in New York. He is a Distinguished Professor of English at the CUNY Graduate Center in New York City.

## JAMES LECESNE
James Lecesne wrote the short film *TREVOR*, which won the 1995 Academy Award for Best Live Action Short and inspired the founding of *The Trevor Project*, the only nationwide 24-hour suicide prevention and crisis intervention lifeline for LGBT and questioning youth. He has written three novels for young adults, and created *The Letter Q*, a collection of letters by queer writers written to their younger selves. Lecesne was the executive producer of *After The Storm*, a documentary film that tells the story of twelve young people living in the wake of Hurricane Katrina. His solo show (*The Absolute Brightness of Leonard Pelkey*) opens Off Broadway in July at the Westside Theater.

## NIKI LEDERER
Born in London, Ontario and raised in Vancouver, Niki Lederer has lived and worked in Williamsburg, Brooklyn since graduating with an MFA from Hunter College in 1996. She earned her BFA at the University of Victoria. Group exhibitions include New York, Los Angeles, Hamburg, and Vancouver. Solo exhibitions include the Art Gallery of Ontario, Rogue Gallery and Open Space in Victoria, B.C. as well as Washington Square Windows, NYU.

## MARY LUM

Mary Lum is a visual artist whose work employs painting, drawing, photography, and collage. Her work has been exhibited recently at Yancey Richardson Gallery, New York (November 2014) and Carroll and Sons, Boston (June 2015), and recently reviewed in *Artforum* (March 2015). She is a 2010 Guggenheim Fellow. Lum lives and works in North Adams, MA.

## SHEILA MALDONADO

Sheila Maldonado is the author of *one-bedroom solo* (Fly by Night Press, 2011), her debut poetry collection. She grew up in Coney Island, New York, across the street from the Atlantic Ocean. Her family hails from Honduras.

## NANCY K. MILLER

Nancy K. Miller's recent books are *What They Saved: Pieces of a Jewish Past*, and *Breathless: An American Girl in Paris*. She is Distinguished Professor of English and Comparative Literature at the Graduate Center, CUNY.

## DAVID MOLESKY

David Molesky is a Brooklyn-based painter and writer. He grew up in Washington DC, and moved west in 1995 to obtain his Bachelor of Arts from UC Berkeley (1999). In 2009, he returned to the US after an eighteen-month apprenticeship with the painter Odd Nerdrum in Iceland, Norway, and Paris. Molesky's work has been featured in numerous museum exhibitions including: the Baltimore Museum of Art; Pasinger Fabrik, Munich, Germany; and the Grand Central Art Center of Cal State Fullerton. The Long Beach Museum of Art has recently added a painting from his series *Hill Fires* to its permanent collection. Many publications including *New American Paintings*, *The Surfer's Journal*, and *Juxtapoz* have featured Molesky and his work.

## LARA MIMOSA MONTES

Lara Mimosa Montes is a writer based in Minneapolis and New York. Her poems and essays have appeared in *Fence, Triple Canopy*, *BOMB*, *recaps*, and elsewhere. She currently teaches feminist and queer theory at the Minneapolis College of Art and Design.

## EMILY MOORE

Emily Moore teaches high school English in New York City. Her poems have appeared in *The New Yorker*, *The Paris Review*, *Ploughshares*, *The Yale Review*, and *Measure*, among others. In 2013, she developed the Kenyon Writing Workshop for Teachers. She may or may not be the only poet to read a sonnet involving Beyoncé on NPR.

## EILEEN MYLES

Poet, novelist, performer, & art journalist, Eileen Myles is the author of nineteen books, including *I Must Be Living Twice/new & selected poem*s and a re-issue of *Chelsea Girls*, both out from Ecco/Harper Collins in 2015. She's a Professor Emeritus at UC San Diego where she directed the writing program and she currently teaches at NYU and Naropa. She is a Guggenheim fellow and in 2014 she received a grant from the Foundation for Contemporary Art. In 2015 she received an art-writing grant from the Clark at Williams College in Massachusetts. She lives in New York and also in Marfa, TX.

## CHRISTINA OLIVARES

Christina Olivares is the author of *No Map of the Earth Includes Stars*, winner of the 2014 Marsh Hawk Press Book Prize, of the 2015 chaplet *Interrupt*, produced by Belladonna* Collaborative, and of *Petition*,

winner of the 2014 Vinyl 45 Chapbook Competition. She is the recipient of two Jerome Foundation Travel and Study Grants, a Teachers and Writers Fellowship, and has twice been nominated for a Pushcart Prize.

### RON PADGETT

Ron Padgett grew up in Tulsa and has lived mostly in New York City since 1960. His *How Long* was Pulitzer Prize finalist in poetry and his *Collected Poems* won the LA Times Prize for the best poetry book of 2014 and the William Carlos Williams Award from the Poetry Society of America. Padgett has translated the poetry of Guillaume Apollinaire, Pierre Reverdy, and Blaise Cendrars. His own work has been translated into eighteen languages. Padgett's new poetry collection is *Alone and Not Alone* (Coffee House Press) and his new translation is *Zone: Selected Poems of Guillaume Apollinaire* (New York Review Books). For more information, go to www.ronpadgett.com.

### HELEN PHILLIPS

Helen Phillips is the author of the novel *The Beautiful Bureaucrat*, the collection *And Yet They Were Happy* (named a notable collection by The Story Prize), and the children's adventure novel *Here Where the Sunbeams Are Green*. She has received a Rona Jaffe Foundation Writers' Award and the Italo Calvino Prize in Fabulist Fiction. Her work has been featured on PRI's *Selected Shorts* and in *Tin House*. An assistant professor at Brooklyn College, she lives in Brooklyn with her husband, artist Adam Douglas Thompson, and their children.

### CHRISTOPHER POTTER

Christopher Potter is the author of *You Are Here*, and *How to Make a Human Being*. He lives in London, and in New York when he is able to.

### LIBBY PRATT

Libby Pratt is an artist, educator, and publisher, originally from Seattle, WA. She is a co-founder of New Draft Collective and Secretary Press. Pratt is the recipient of numerous awards and residencies and her personal work is exhibited internationally. Currently she is the Director at Baxter St at the Camera Club of New York and teaches at City College of New York, CUNY.

### SAL RANDOLPH

Sal Randolph is an artist who lives in Brooklyn and works between language and action. Her *Ambience Scores* have been exhibited and performed at Calico Gallery, Haverford College, Kunstverien Göttingen, Princeton University, Soapbox Gallery, and Rover Dig. Other projects have been shown recently at Raygun Projects in Toowoomba, Australia, at the Moore College Galleries in Philadelphia, and in *Cabinet*. She has taught as a fellow at Princeton and a visiting artist at HEAD Geneva, Institute for Raüm Experimente, Mildred's Lane, RISD, and elsewhere. New poems are in *Queen Mob's Teahouse*, *Pith*, and *Otolith*.

### MATTHEW SANDAGER

Matthew Sandager is a photographer, filmmaker, and animator based in New York. His work has appeared in publications and has been exhibited in gallery shows and film festivals, both in New York and around the world. And after all these years he still loves Legos.

### CEDAR SIGO

Cedar Sigo was raised on the Suquamish Reservation in the Pacific Northwest and

studied at The Jack Kerouac School of Disembodied Poetics at the Naropa Institute. He is the author of eight books and pamphlets of poetry, including *Language Arts* (Wave Books, 2014), *Stranger in Town* (City Lights, 2010), *Expensive Magic* (House Press, 2008), and two editions of *Selected Writings* (Ugly Duckling Presse, 2003 and 2005). He lives in San Francisco.

### RYAN SKRABALAK

Ryan Skrabalak is a poet currently living in his hometown of Bethlehem, New York. You can find past works of his in *Slice, Stone Canoe, The Brooklyn Review, By The Overpass,* and the two zine series *Having A Whiskey Coke With You* and *Post-Apocalyptic Poets of Deep Brooklyn.* Would you like to be friends with him? Then we can stay up all night and listen to jazz music.

### LULU SYLBERT

Lulu Sylbert is a writer and teaches at Brooklyn College. She has been a fellow at MacDowell, Yaddo, Ucross, and the Millay Colony.

### AMANDA TOMME

Amanda Tomme was born and raised in Las Vegas, NV, and is now living in Brooklyn, NY with her partner and their son. Also working under the name Joan Tick, she is a writer and musician who has released music and toured with NYC-based psych-folk bands, including The Phenomenal Handclap Band, Dune and Oak, and Magmana. Her written work has appeared in *Joyland*, *Zen Monster*, *Flavorwire*, and *Max's Kansas City Blog.*

### DAVID TRINIDAD

David Trinidad's books include *Dear Prudence: New and Selected Poems* (2011)

and *Peyton Place: A Haiku Soap Opera* (2013), both published by Turtle Point Press. *Notes on a Past Life* is forthcoming in 2016 from BlazeVOX [books]. He is also the editor of A *Fast Life: The Collected Poems of Tim Dlugos* (Nightboat Books, 2011). Trinidad lives in Chicago, where he is a Professor of Creative Writing/Poetry at Columbia College.

### JOAQUIN TRUJILLO

Joaquin Trujillo is an artist, curator, editor and photographer who lives and works between L.A., Mexico and New York City. His potent yet subtle approach to color and texture emulates a structured slippage of heritage. Building upon the dichotomy of his Mexican heritage and American education, he weaves together an uncanny modality of childhood innocence across culture, place and time.

### JASON ZUZGA

Jason Zuzga is currently finishing a PhD in English at the University of Pennsylvania. He is the Other Editor of Fence and the author of the poetry collection *HEAT WAKE* to be published by Saturnalia Books in March 2016.

Matthew Burgess is a doctoral lecturer at Brooklyn College. He is the author of a poetry collection, *Slippers for Elsewhere* (UpSet Press, 2014) and a children's book, *Enormous Smallness: A Story of E. E. Cummings* (Enchanted Lion Books, 2015). Burgess has been a poet-in-residence in New York City public schools since 2001, and is a contributing editor of *Teachers & Writers Magazine*. He received an MFA in Poetry from Brooklyn College and a PhD in Literature from the CUNY Graduate Center.

Bachelard, Gaston. *The Poetics of Reverie*. Trans. Daniel Russell. New York: Orion Press, 1969. Print.

—*The Poetics of Space*. Trans. Maria Jolas. Boston: Beacon Press, 1994. Print.

Benjamin, Walter. "One Way Street." *Selected Writings: Vol. 1*. Cambridge: Harvard University Press, 1999.

Caldwell, Lesley and Angela Joyce. *Reading Winnicott*. New York: Routledge, 2011.

Freud, Sigmund. *The Freud Reader*. Ed. Peter Gay. Norton Paperback Ed. New York: W.W. Norton, 1995. Print.

Huizinga, Johan. *Homo Ludens: A Study of the Play Element in Culture*. Boston: The Beacon Press, 1955.

Nabokov, Vladimir. *Speak, Memory : An Autobiography Revisited*. Rev ed. New York, N.Y.: Vintage International, 1989. Print.

Welch, Denton. *In Youth Is Pleasure & I Left My Grandfather's House*. Cambridge, MA: Exact Change, 1994. Print.

Woolf, Virginia. *Moments of Being*. Ed. Jeanne Schulkind. 2nd ed. San Diego: Harcourt Brace Jovanovich, 1985. Print. (A Harvest Book.)

—*A Room of One's Own*. London, England: Penguin Classics, 2000. Print.

Brett Bell, *Henry*, 2014, digital image, 4" x 6"

Aram Jibilian, *Morning in the Bedroom with Five Moons*, 2015, digital image, 10" x 12"

Wayne Koestenbaum, *Nightwood*, 2014, oil, flashe, acrylic, ink, and acrylic marker on canvas, 48" x 36"

Mary Lum, *Situation 5*, 2008, comic collage and acrylic on paper, 10" x 8"

Joaquin Trujillo, *Soñando para estar despierto. De la serie Nueva, Doce y Treinte* & *Por que fué, Por que es, Por que Será. De la series Nueva, Doce y Treinta*, 2014, archival pigment prints, 26" x 32"

Kris Di Giacomo, *Liftoff*, 2015, drawing and mixed-media digital collage, 14" x 11"

Matthew Sandager, *Dream House (1983/2015)*, 2015, digital image, 8" x 12"

Niki Lederer, *Chewbacca*, 2015, recycled plastic bottles, hex nuts, and bolts, 74" x 36" x 36"

David Molesky, *First Studio (Circa 1981)*, 2015, oil on canvas board, 14" x 11"

Nancy K. Miller, *Hudson River School*, c-print, 5" x 7"

Michi Jigarjian, *James at Dusk*, 2014, digital c-print, 8" x 10"

Bill Kelly, *Waiting for a Shudder*, 2013, silverprint photograph, 6" x 10"

Libby Pratt, *03:45, 1°09'29"N 86°55'12"W, 3.5 knots WSW. Watch almost over and not much happening. Still no wind, motor sailing along, some lights off to port but far away. We'll likely cross the equator sometime tomorrow afternoon at this rate. Pistachios.*, 2014, archival pigment print, 16" x 20"

# SECRETARY PRESS

PO Box 1950
New York, NY 10013
info@secretarypress.com
secretarypress.com

Secretary Press was founded by New Draft Collective. New Draft Collective is
Michi Jigarjian and Libby Pratt. As a collective they engage as a collaborative
art practice, publisher and facilitator. The aim is to publish books that document
and augment contemporary conversations around and about art and culture.

Secretary Press is currently distributed through Small Press Distribution.

DESIGN
L+L

COPYEDITING
Tom Roberge

TYPEFACES
Arnhem Pro, AG Schoolbook

PRINTING
Printed by J. S. McCarthy Printers in Augusta, ME

IMAGES
"The Carina Nebula" by ESO/IDA/Danish 1.5 m/R.Gendler, J-E. Ovaldsen, C. Thöne, and
      C. Feron is licensed under CC-BY 4.0 / Desaturated from original
"(Tsander) Large Impact Crater, Lunar Surface" by the NASA Lunar Reconnaissance Orbiter
      Team is courtesy NASA/JPL-Caltech
"Daytime Moon" by Alana Sise is licensed under CC-BY 2.0 / Desaturated from original /
      Found at https://www.flic.kr/alanasise/7889309800/
"White curtain in warm light" by Christoph Michels is licensed under CC-BY-SA 3.0 /
      Desaturated from original / Found at https://commons.wikimedia.org/wiki/
      File:Curtain_light.JPG

About the Editor photo by Aram Jibilian, 2015